POPE FRANCIS
& THE VIRGIN MARY:
A Marian Devotion

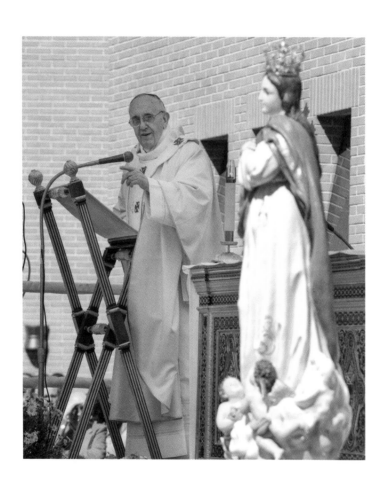

POPE FRANCIS
& THE VIRGIN MARY:
A Marian Devotion

edited by
Vincenzo Sansonetti

RIZZOLI
NEW YORK

New York Paris London Milan

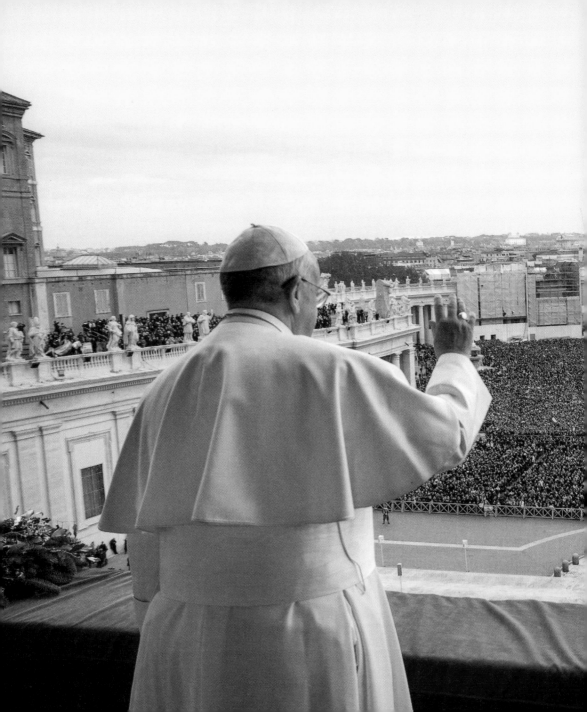

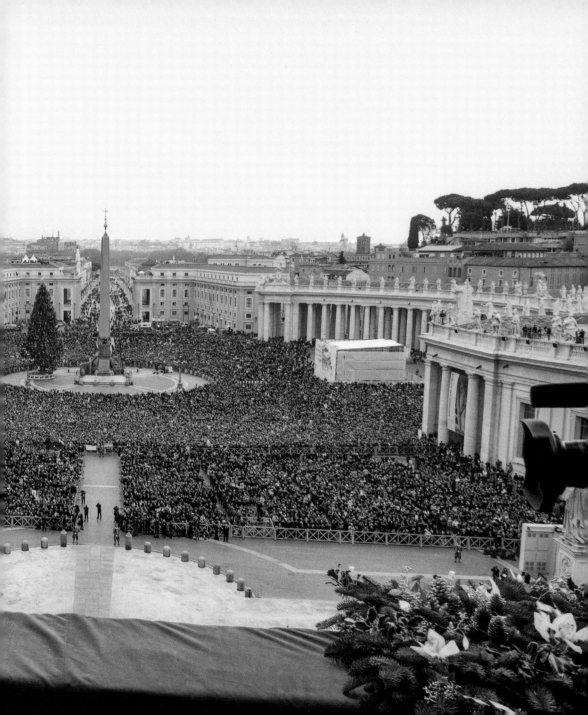

Mother, lead us by the hand

by Vincenzo Sansonetti

"I entrust my ministry to the powerful intercession of Mary, our Mother, Mother of the Church." It is the morning of March 15, 2013. After having been Pope for only two days, Francis immediately and very openly entrusts himself to the protection of Our Lady. Addressing the cardinals gathered in Clementine Hall, he adds, "Under her maternal gaze, may each one of you continue gladly along your path, attentive to the voice of her divine Son, strengthening your unity, persevering in your common prayer and bearing witness to the true faith in the constant presence of the Lord." The day before, on March 14, he had performed his first public gesture as Holy Father, paying homage to Our Lady, *Salus Populi Romani* ("Protectress of the Roman People"), at the Papal Basilica of St. Mary Major with prayers and a bouquet of flowers. The trip wasn't new for him; as an archbishop, he went there often to pray.

A strong devotion for the Mother of God has always been a big part of Bergoglio's life and pastoral work. Fr. José Daniel Blanchoud, rector of the shrine of Our Lady of Luján, patroness

of Argentina, confirms his devotion. "He went to the Basilica to ask Mary to be with him and protect him in this new ministry that the Church asks of him." Fr. Blanchoud then added his own news: "Over the last few days [at the beginning of the pontificate, *Ed.*] we've had more pilgrims than we usually do. The election has set people in motion; it's made them move closer to the Virgin Mary. People know the Pope's devotion to Our Lady. They are coming for confession." The Mary of Argentine devotion is similar to the Madonna of Loreto, Italy, (though the wood of the former is white, and the latter is black). She also has a tie to Our Lady of Pompeii, because her feast is celebrated on May 8, the same day that the people of Pompeii say the *supplica* litany asking for her help. Bergoglio never missed that day at the shrine of Luján, about 45 miles from Buenos Aires, where each year a group of about a million young people conclude a long pilgrimage. The future Pope also frequently visited the small, simple church dedicated to Our Lady of Caacupé, called Our Lady of the "Villas Miserias," impoverished neighborhoods surrounding the shrine. In a homily on November 7, 2011, the future Pontiff said, "to be able to enter humanly into our history, he needed a mother, and he asked us for one. She is the Mother to whom we look today—the daughter of our people, the handmaid, the pure, the only one of God; the discreet one who makes space for her Son to fulfill the sign, who is always

enabling this reality but not as its owner or even as an actor, but as a servant; the star that knows how to fade so that the sun can show itself."

Pope Francis's intimate connection with the Blessed Mother is also displayed in his coat of arms, first as bishop and now as Pope. There is a star on the lower left of the shield, which in the history of heraldic symbolism has always stood for the Virgin Mary, mother of Christ and of the Church. He would refer to her as the "star of the New Evangelization." The tie goes back a long way, to the day of his baptism, and was later cultivated especially through his devotion to Mary Undoer of Knots. He was baptized on Christmas Day in 1936 at the basilica dedicated to Mary Help of Christians in Barrio Flores in Buenos Aires. The stately, Neo-Romanesque church, built in the "Lombard style," was meaningful to his parents, who had gone there since they were young, and as a child Jorge Mario spent entire days there. Once he became bishop and then cardinal, he did not forget "his" basilica. He returned each year on May 24— the feast day of Mary Help of Christians—and presided over the Sacred Liturgy. Throughout the year, he often showed up unannounced, dressed simply as a priest. He would enter the church, sit down next to the statue of Our Lady, and spend time in silent prayer. Afterward, he would return to the Archbishop's residence, always traveling by city bus.

———

Bergoglio's devotion to Mary Undoer of Knots originated in the mid-1980s, during the time that he was in Bavaria, Germany to finish his doctoral dissertation. It all began from the moving "discovery" of a painting full of color and joy that was housed in a church (in the care of the Jesuits) dedicated to St. Peter am Perlach in Augsburg. The oil on canvas painting dates back to the eighteenth century and is attributed to the local artist Johann Georg Schmidtner. It was commissioned by a noble prelate to commemorate the invaluable assistance that his grandparents had received from Our Lady during a period of great difficulty in their marriage. The untitled work of art, in a Venetian style with some Baroque influence, is all but ignored by most of the faithful and by visitors to the church, but Bergoglio was deeply moved and comforted by it. Our Lady is pictured without the infant Jesus in her arms, standing on a crescent moon and crushing a serpent, which represents the devil, under her foot. At the same time, her eyes are full of careful attention, intent upon untangling the knots that ensnare a ribbon held high by two angels. The ribbon in the hands of the angel on the right is full of knots, but on the left side the ribbon hangs freely from the hands of Our Lady, merely supported by the hands of the angel who displays it to the faithful as a reassurance that their prayers have been answered. Bergoglio knelt in front of the mystery of this scene and felt that, inside of him, knots began

to be loosened. When he returned to Argentina, he tirelessly promoted the familiarity with Mary Undoer of Knots amongst the faithful, dedicating chapels in her honor and even using the image as his personal "business card." The devotion, now widespread in Latin America, is also taking root in Italy and the United States. Following the Marian prayer in St. Peter's Square on October 12, 2013, giving a full and appropriate catechesis on the role of Mary in our lives, Pope Francis made a clear reference to his devotion. He said, "Mary, whose 'yes' opened the door for God to undo the knot of ancient disobedience, is the Mother who patiently and lovingly brings us to God, so that He can untangle the knots of our soul by His fatherly mercy." It is she who "leads us by the hand" as a Mother, "to the embrace of the Father of mercies."

In the richly illustrated pages of this book, which follows in the line of the book *Francis: The People's Pope* (an anthology of quotations from the first months of his pontificate), we have collected references and invocations to Mary from Pope Francis's speeches, homilies and public prayers. Mary "helps us to grow, to confront life, to be free," (Address at the Basilica of St. Mary Major on May 4, 2013). The quotations are in chronological order with titles given by the editor.

August 15, 2014

(Feast of the Assumption of the Blessed Virgin Mary)

———

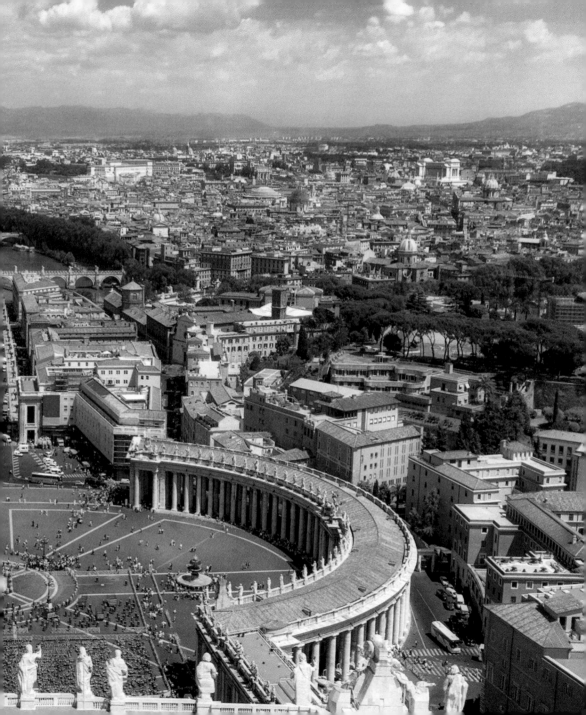

Grace

My prayer for all of us is that the Holy Spirit, through the intercession of the Blessed Virgin Mary, our Mother, will grant us this grace: to walk, to build, to profess Jesus Christ crucified. Amen.

<div align="right">

Homily of the Mass Pro Ecclesia *celebrated*
with the Cardinal Electors in the Sistine Chapel, March 14, 2013

</div>

Gladness

I entrust my ministry and your ministry to the powerful intercession of Mary, our Mother, Mother of the Church. Under her maternal gaze, may each one of you continue gladly along your path, attentive to the voice of her divine Son, strengthening your unity, persevering in your common prayer and bearing witness to the true faith in the constant presence of the Lord.

Address to the Cardinals, March 15, 2013

Mercy

He is the loving Father who always pardons, who has a heart of mercy for all of us. And let us too learn to be merciful to everyone. Let us invoke the intercession of Our Lady who held in her arms the Mercy of God made man.

Angelus, *March 17, 2013*

Newness

On this radiant night, let us invoke the intercession of the Virgin Mary, who treasured all of these events in her heart [...] and ask the Lord to give us a share in his Resurrection. May he open us to the newness that transforms, to the beautiful surprises of God.

Homily of the Easter Vigil, March 30, 2013

Cana

Our Lady always takes us to Jesus. Call upon Our Lady, and she will say what she said at Cana: "Do whatever he tells you!" She always leads us to Jesus. She was the first person to act in the name of Jesus.

Homily in the Chapel of the Domus Sanctae Marthae, April 5, 2013

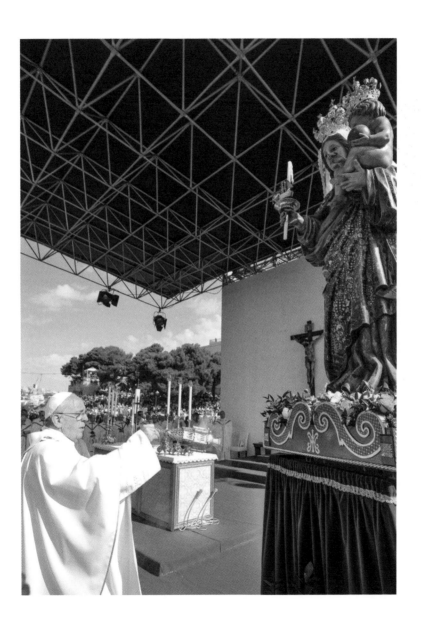

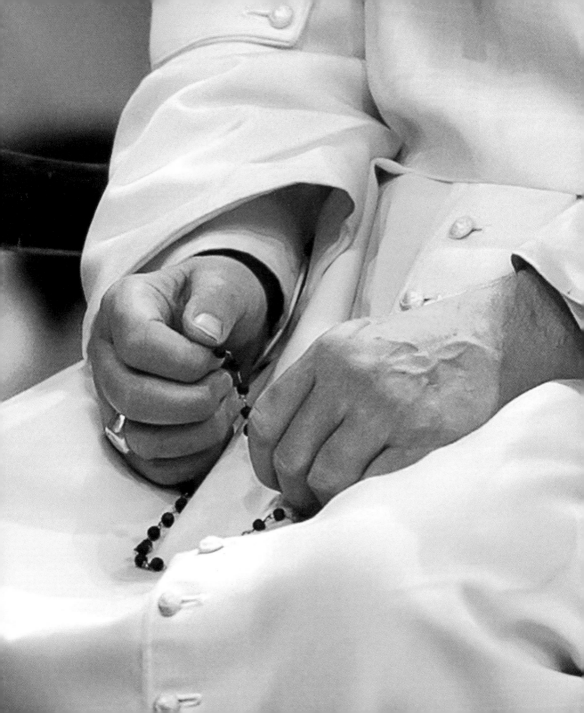

Forgiveness

Together let us pray to the Virgin Mary that she help us, Bishop and People, to walk in faith and charity, ever trusting in the Lord's mercy: he always awaits us, loves us, has pardoned us with his blood and pardons us every time we go to him to ask his forgiveness. Let us trust in his mercy!

Regina Coeli, *April 7, 2013*

Annunciation

At the Annunciation Mary humbles herself: she did not understand clearly, but she was free: she understood only the essential part—and she said yes. She was humble: "May God's will be done." She entrusted her soul to God's will.

Homily in the Chapel of the Domus Sanctae Marthae, April 8, 2013

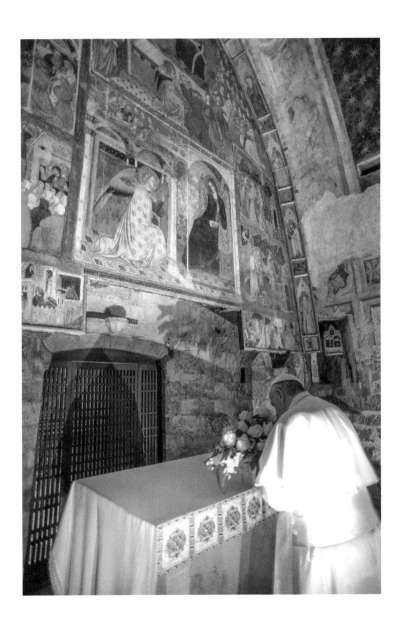

Manner

It is […] the manner of Mary and Joseph, which shows that all of God's love, in order to come to us, takes the path of humility. The humble God who wished to walk with his people. […] Let us gaze upon Mary, let us look to Joseph, and let us ask for the grace of humility.

Homily in the Chapel of the Domus Sanctae Marthae, April 8, 2013

Obedience

May the Virgin Mary, [...] model of docility and obedience to the Word of God, teach you to recognize fully the inexhaustible riches of Sacred Scripture, not only through intellectual research but also in prayer and in the whole of your life as believers.

Audience to the Members of the Pontifical Biblical Commission, April 12, 2013

Brotherly Love

Let us ask for the help of Mary Most Holy so that the Church throughout the world may proclaim the Resurrection of the Lord with honesty and courage and give credible witness to it with signs of brotherly love. Brotherly love is the closest testimony we can give that Jesus is alive with us, that Jesus is risen.

Regina Coeli, *April 14, 2013*

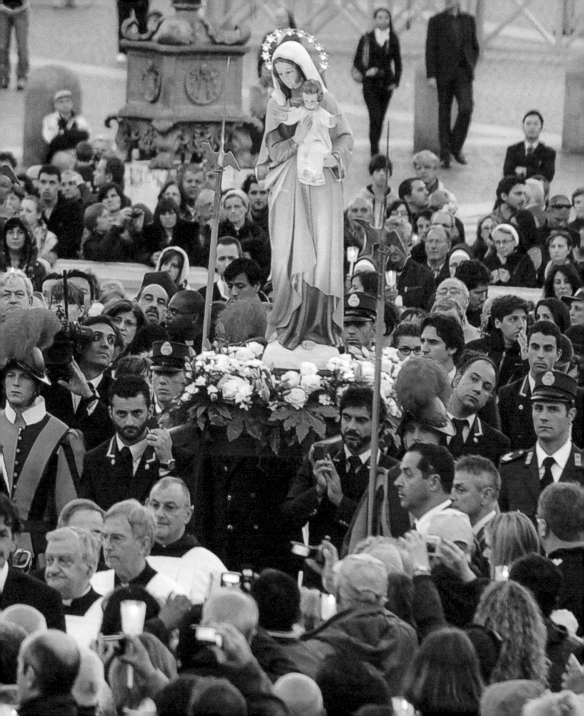

Protection

Let us pray to Our Lady to protect us and in times of spiritual turbulence the safest place is beneath Our Lady's cape. Indeed, she is the Mother who cares for the Church. And in this season of martyrs, she is, as it were, the protagonist of protection. She is Mother.

Homily in the Chapel of the Domus Sanctae Marthae, April 15, 2013

Encouragement

Being a Christian does not mean making a career of studying to become a lawyer or a Christian doctor, no. Being a Christian ... is a gift that makes us go forward with the power of the Spirit, the proclamation of Jesus Christ. [...] Mary, during the persecution of the first Christians prayed so much and animated those who were baptized to go forward with courage.

Homily in the Chapel of the Domus Sanctae Marthae, April 17, 2013

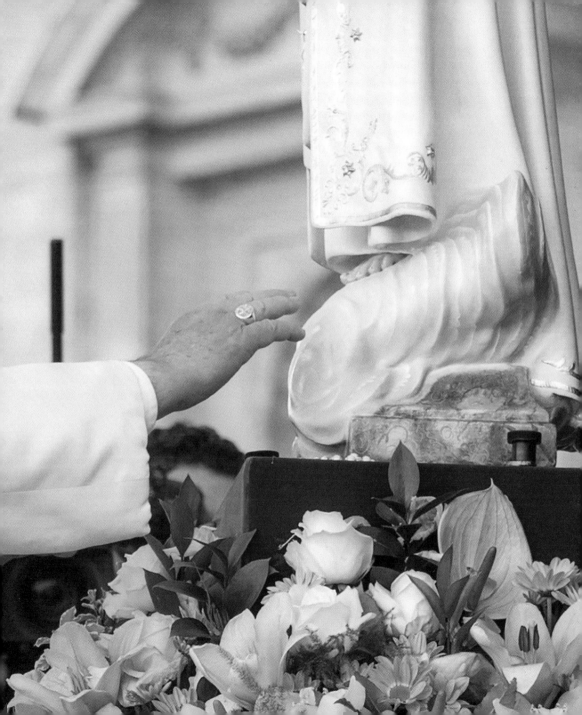

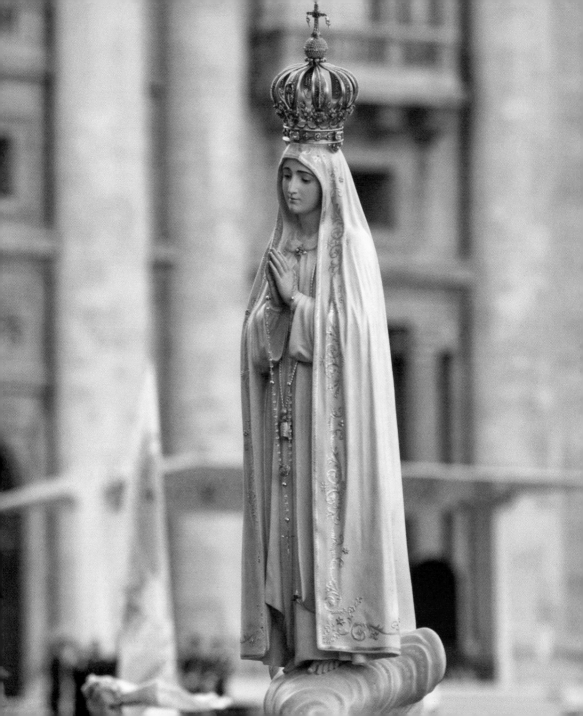

Voice

Let us invoke the intercession of Mary who is the woman of "yes." Mary said "yes" throughout her life! She learned to recognize Jesus' voice from the time when she carried him in her womb. May Mary, our Mother, help us to know Jesus' voice better and better and to follow it, so as to walk on the path of life!

Regina Coeli, *April 21, 2013*

Together

All together, we are one family in the Church who is our mother. […] Let us ask the Madonna, who is our Mother, to give us the grace of joy, of spiritual joy to journey through this story of love.

Homily in the Chapel of the Domus Sanctae Marthae, April 24, 2013

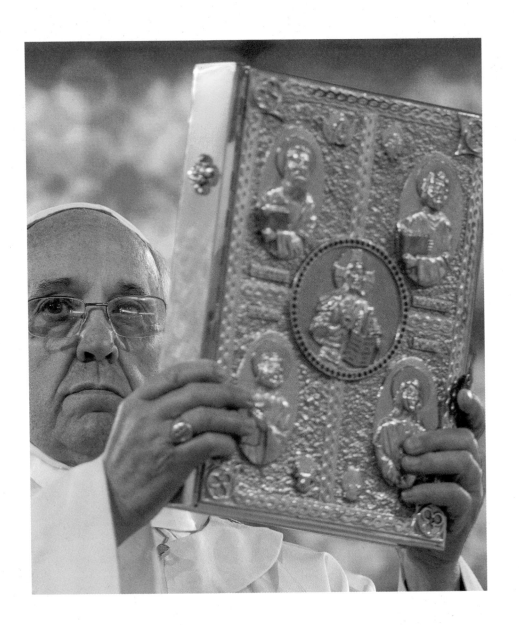

Word of God

The Virgin Mary teaches us what it means to live in the Holy Spirit and what it means to accept the news of God in our life. She conceived Jesus by the work of the Holy Spirit, and every Christian, each one of us, is called to accept the Word of God, to accept Jesus inside of us and then to bring him to everyone.

Regina Coeli, *April 28, 2013*

Strength

Mary invoked the Holy Spirit with the Apostles in the Upper Room: we too, every time that we come together in prayer, are sustained by the spiritual presence of the Mother of Jesus, in order to receive the gift of the Spirit and to have the strength to witness Jesus Risen.

Regina Coeli, *April 28, 2013*

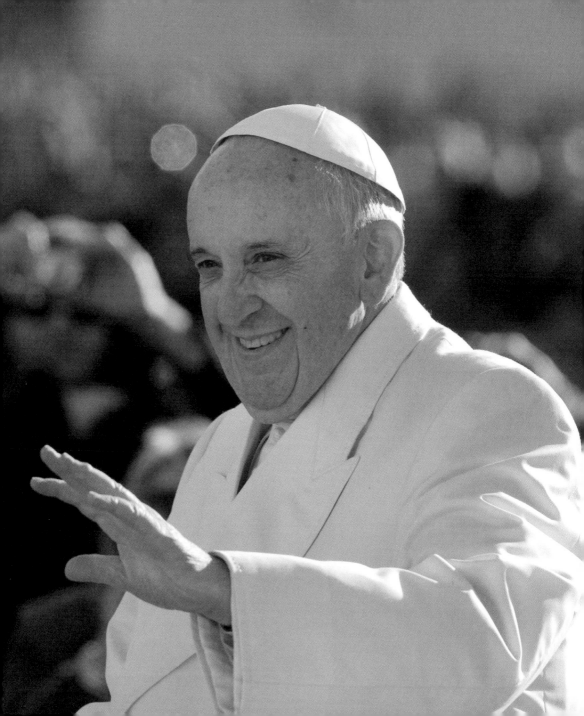

Rosary

Reciting the Hail Mary, we are led to contemplate the mysteries of Jesus, that is, to reflect on the key moments of his life, so that, as with Mary and St. Joseph, he is the center of our thoughts, of our attention and our actions. It would be nice if, especially in this month of May, we could pray the Holy Rosary together among family, with friends, in the parish, or some prayer to Jesus and the Virgin Mary!

General Audience, May 1, 2013

Faithfulness

Let us ask St. Joseph and the Virgin Mary to teach us to be faithful to our daily tasks, to live our faith in the actions of everyday life and to give more space to the Lord in our lives, to pause to contemplate his face.

General Audience, May 1, 2013

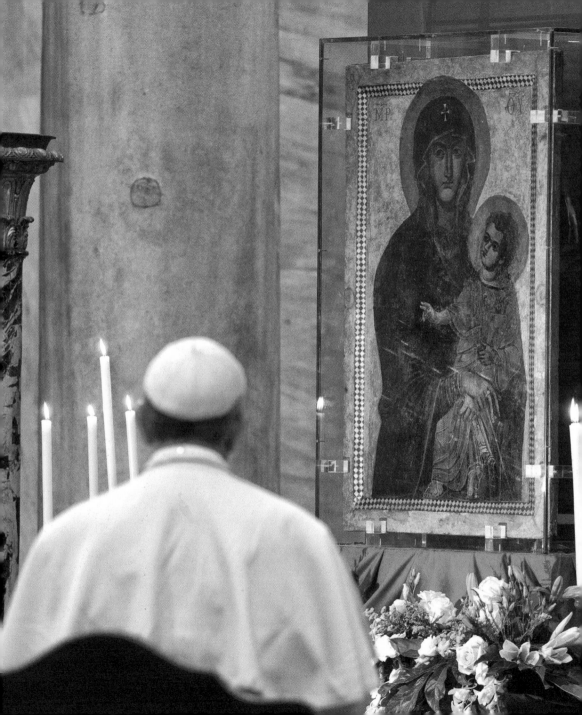

Health

Mary is a mother, and a mother worries above all about the health of her children, she knows how to care for them always with great and tender love. Our Lady guards our health. What does this mean: Our Lady guards our health? I think mainly of three things: she helps us grow, to confront life, to be free.

Holy Rosary in the Basilica of St. Mary Major, May 4, 2013

Responsibility

The Gospel of St. Luke tells us that, in the family of Nazareth, Jesus "grew and became strong, filled with wisdom; and the favor of God was upon him" (*Lk* 2:40). Our Lady does just this for us: she helps us to grow as human beings and in the faith, to be strong and never to fall into the temptation of being human and Christians in a superficial way, but to live responsibly, to strive ever higher.

Holy Rosary in the Basilica of St. Mary Major, May 4, 2013

Choices

Freedom is given to us so that we know how to make good decisions in life! Mary as a good mother teaches us to be, like her, capable of making definitive decisions; definitive choices, at this moment in a time controlled by, so to speak, a philosophy of the provisional. It is very difficult to make a lifetime commitment. And she helps us to make those definitive decisions in the full freedom with which she said "yes" to the plan God had for her life.

Holy Rosary in the Basilica of St. Mary Major, May 4, 2013

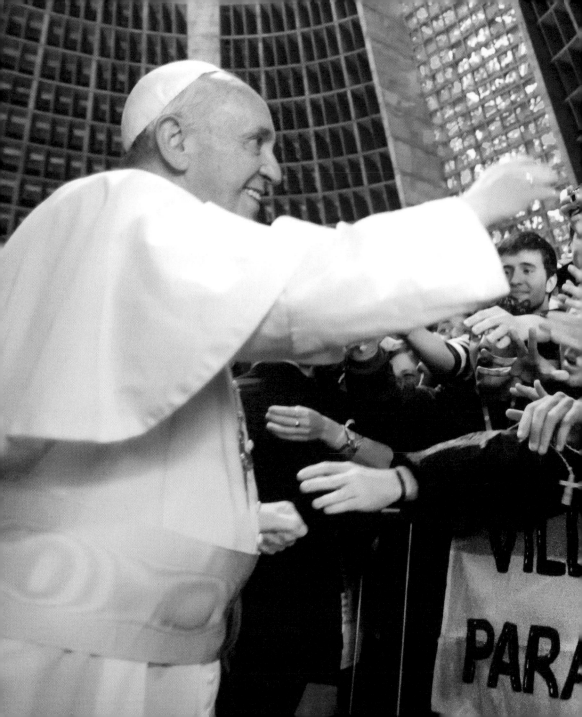

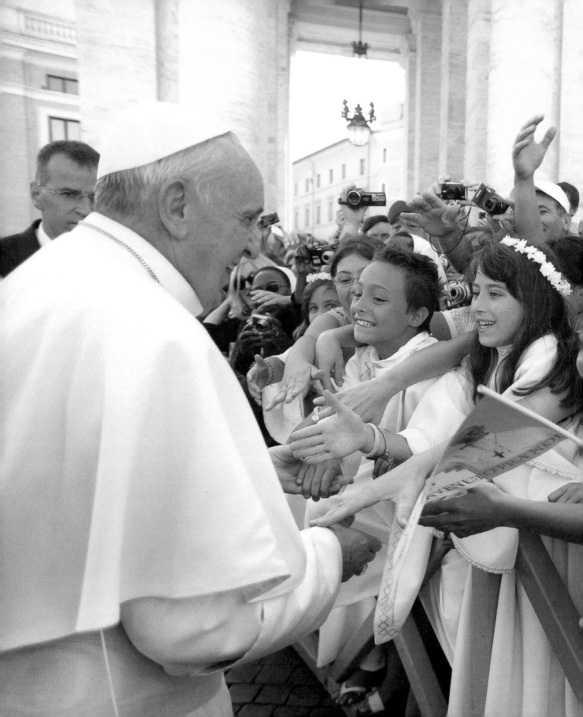

Making Room

Let us ask Our Lady to teach us how to live out our faith in our daily lives and to make more room for the Lord.

Tweet, May 4, 2013

Spiritual Fruitfulness

The consecrated woman is a mother; she must be a mother, not a "spinster!" Excuse me for speaking like this, but motherhood in the consecrated life is important, this fruitfulness! May this joy of spiritual fecundity motivate your life; be mothers, as a figure of Mary, Mother, and of Mother Church. It is impossible to understand Mary without her motherhood; it is impossible to understand the Church apart from her motherhood, and you are symbols of Mary and the Church.

Plenary Assembly of the International Union Of Superiors General, May 8, 2013

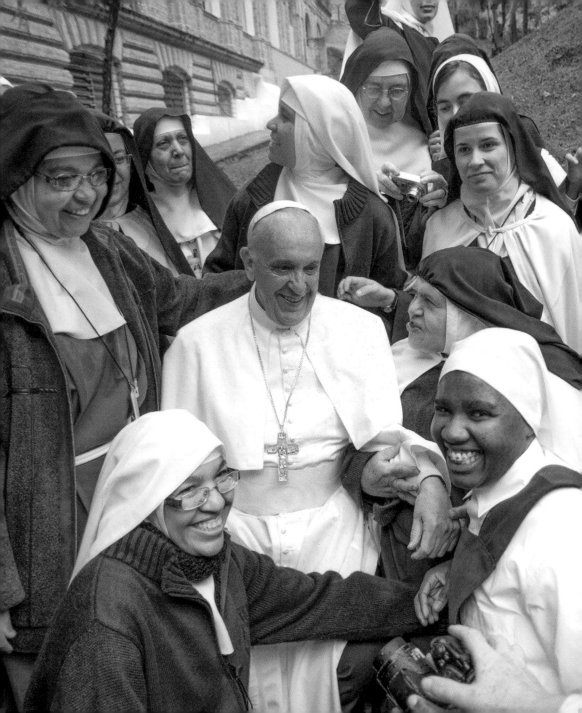

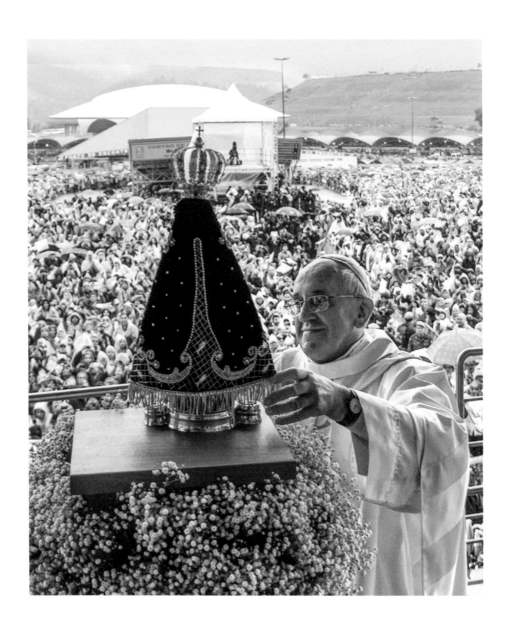

Openness

We must learn from Mary, and we must imitate her unconditional readiness to receive Christ in her life.

Tweet, May 18, 2013

Listening

Mary is attentive to God. She listens to God. Mary also listens to the events, that is, she interprets the events of her life, she is attentive to reality itself and does not stop at the surface but goes to the depths to grasp its meaning. [...] This is also true in our life: listening to God who speaks to us and listening also to daily reality, paying attention to people, to events, because the Lord is at the door of our life and knocks in many ways.

Marian Celebration in St. Peter's Square, May 31, 2013

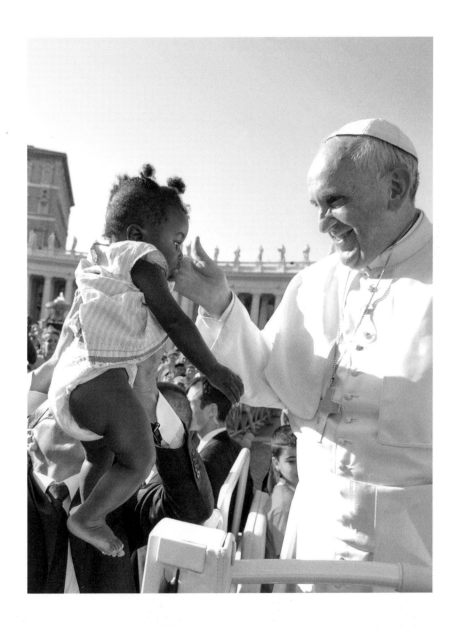

Against the Tide

In the Annunciation, in the Visitation and at the wedding of Cana Mary goes against the tide. Mary goes against the tide; she listens to God, she reflects and seeks to understand reality and decides to entrust herself totally to God. Although she is with child, she decides to visit her elderly relative and she decides to entrust herself to her Son with insistence so as to preserve the joy of the wedding feast.

Marian Celebration in St. Peter's Square, May 31, 2013

Decision

Sometimes we know what we have to do, but we lack the courage to do it. Let us learn from Mary how to make decisions, trusting in the Lord.

Tweet, June 3, 2013

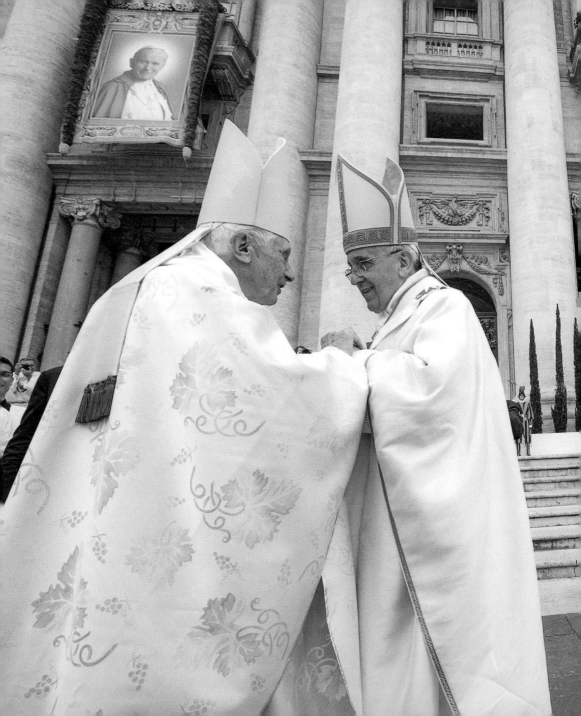

Promise

In Mary, the Daughter of Zion, is fulfilled the long history of faith of the Old Testament, with its account of so many faithful women, beginning with Sarah: women who, alongside the patriarchs, were those in whom God's promise was fulfilled and new life flowered. In the fullness of time, God's word was spoken to Mary and she received that word into her heart, her entire being, so that in her womb it could take flesh and be born as light for humanity.

Encyclical Letter Lumen Fidei, *June 29, 2013*

Origin

Because of her close bond with Jesus, Mary is strictly connected to what we believe. As Virgin and Mother, Mary offers us a clear sign of Christ's divine sonship. The eternal origin of Christ is in the Father. He is the Son in a total and unique sense, and so he is born in time without the intervention of a man.

Encyclical Letter Lumen Fidei, *June 29, 2013*

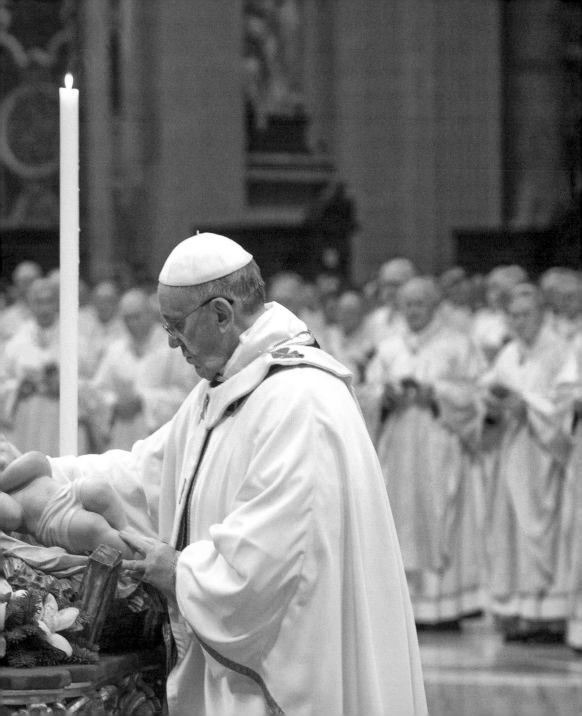

History

Mary's true motherhood also ensured for the Son of God an authentic human history, true flesh in which he would die on the Cross and rise from the dead. Mary would accompany Jesus to the Cross (cf. *Jn* 19:25), whence her motherhood would extend to each of his disciples (cf. *Jn* 19:26-27). She would also be present in the Upper Room after Jesus' Resurrection and Ascension, joining the Apostles in imploring the gift of the Spirit.

Encyclical Letter Lumen Fidei, *June 29, 2013*

Call

Mother, help our faith! Open our ears to hear God's word and to recognize his voice and call. Awaken in us a desire to follow in his footsteps, to go forth from our own land and to receive his promise. Help us to be touched by his love, that we may touch him in faith. Help us to entrust ourselves fully to him and to believe in his love, especially at times of trial, beneath the shadow of the cross, when our faith is called to mature. Sow in our faith the joy of the Risen One. Remind us that those who believe are never alone. Teach us to see all things with the eyes of Jesus, that he may be light for our path.

Encyclical Letter Lumen Fidei, *June 29, 2013*

Fear

On the day of Pentecost, the Madonna was there with the disciples: And where the mother is, the children are safe! […] If we are afraid, we know that the Mother is with us. And like children who are a little afraid, let us go to her—and she, as the ancient antiphon says, —"will protect us with her cloak, with her motherly protection."

Homily in the Chapel of the Domus Sanctae Marthae, July 6, 2013

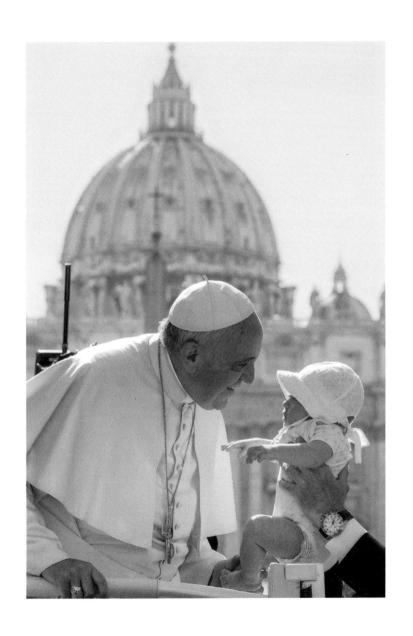

Mission

When the Church looks for Jesus, she always knocks at his Mother's door and asks: "Show us Jesus." It is from Mary that the Church learns true discipleship. That is why the Church always goes out on mission in the footsteps of Mary.

Homily of the Mass in the Basilica of the Shrine of Our Lady of Aparecida (Brazil), July 24, 2013

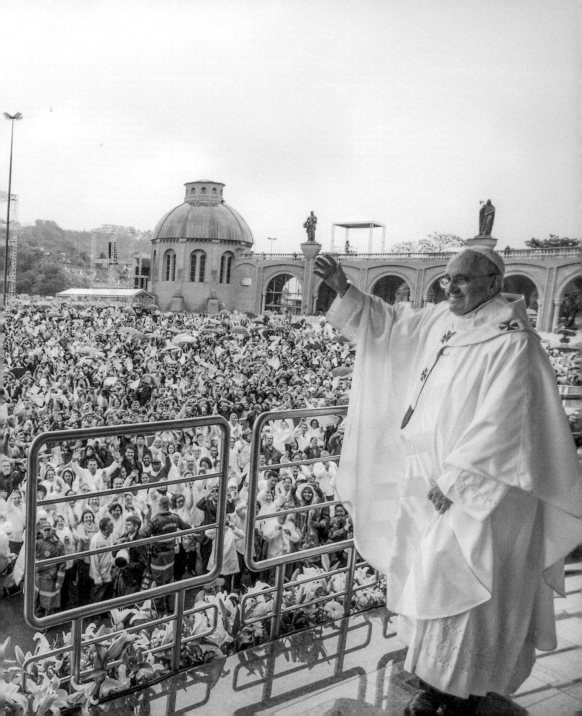

Education

I […] come to knock on the door of the house of Mary—who loved and raised Jesus—that she may help all of us, pastors of God's people, parents and educators, to pass on to our young people the values that can help them build a nation and a world which are more just, united, and fraternal.

Homily of the Mass in the Basilica of the Shrine
of Our Lady of Aparecida (Brazil), July 24, 2013

Intercession

If we walk in hope, allowing ourselves to be surprised by the new wine which Jesus offers us, we have joy in our hearts and we cannot fail to be witnesses of this joy. Christians are joyful, they are never gloomy. God is at our side. We have a Mother who always intercedes for the life of her children, for us.

Homily of the Mass in the Basilica of the Shrine
of Our Lady of Aparecida (Brazil), July 24, 2013

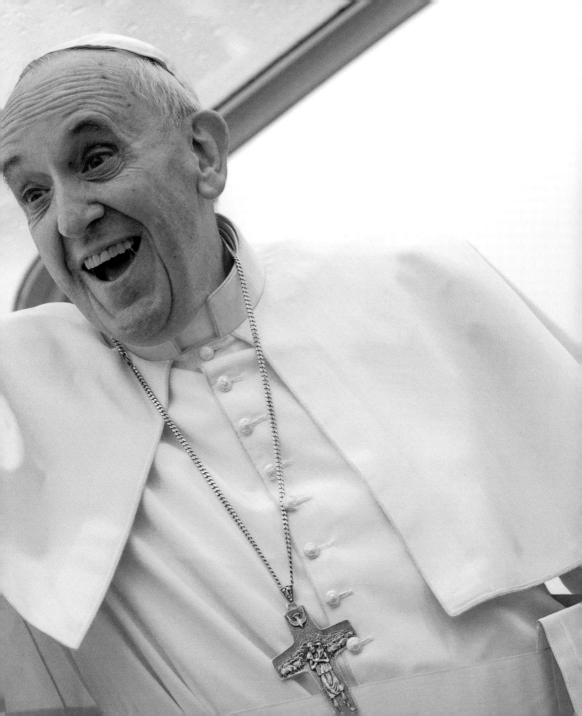

Help

Never forget, young friends: the Virgin Mary is our Mother and with her help we can remain faithful to Christ.

Tweet, July 24, 2013

Tenderness

Bringing the Gospel is bringing God's power to pluck up and break down evil and violence, to destroy and overthrow the barriers of selfishness, intolerance and hatred, so as to build a new world. Dear young friends, Jesus Christ is counting on you! The Church is counting on you! The Pope is counting on you! May Mary, Mother of Jesus and our Mother, always accompany you with her tenderness.

Homily of the Mass for the XXVIII World Youth Day,
Rio de Janeiro (Brazil), July 28, 2013

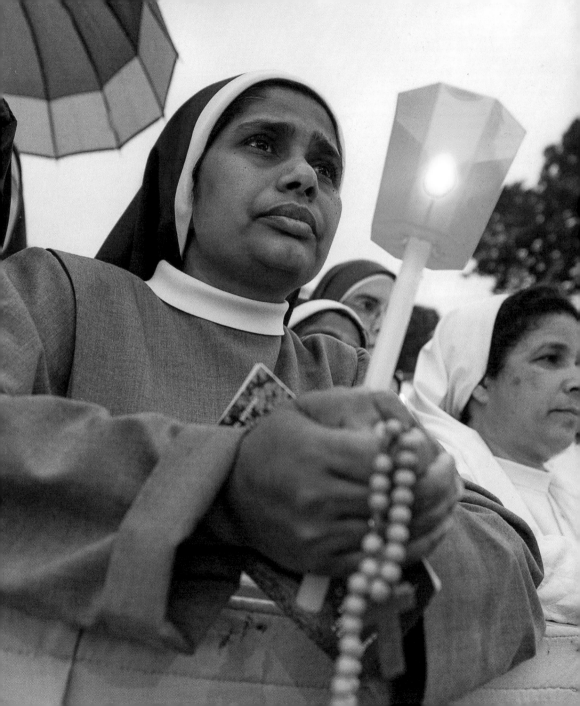

Struggle

Mary accompanies us, struggles with us, sustains Christians in their fight against the forces of evil. [...] Prayer with Mary, especially the Rosary, has this "suffering" dimension, that is of struggle, a sustaining prayer in the battle against the evil one and his accomplices. The Rosary also sustains us in the battle.

Homily on the Solemnity of the Assumption
of the Blessed Virgin Mary, Castel Gandolfo, August 15, 2013

Resurrection

Paul, writing to the Corinthians, insists that being Christian means believing that Christ is truly risen from the dead. Our whole faith is based upon this fundamental truth, which is not an idea but an event. Even the mystery of Mary's Assumption body and soul is fully inscribed in the Resurrection of Christ. The Mother's humanity is "attracted" by the Son in his own passage from death to life. Once and for all, Jesus entered into eternal life with all of the humanity he had drawn from Mary; and she, the Mother, who followed him faithfully throughout her life, followed him with her heart, and entered with him into eternal life, which we also call Heaven, Paradise, the Father's house.

Homily on the Solemnity of the Assumption
of the Blessed Virgin Mary, Castel Gandolfo, August 15, 2013

Martyrdom

Mary also experienced the martyrdom of the Cross: the martyrdom of her heart, the martyrdom of her soul. She lived her Son's Passion to the depths of her soul. She was fully united to him in his death, and so she was given the gift of resurrection. Christ is the first fruits from the dead and Mary is the first of the redeemed, the first of "those who are in Christ." She is our Mother, but we can also say that she is our representative, our sister, our eldest sister, she is the first of the redeemed, who has arrived in Heaven.

Homily on the Solemnity of the Assumption
of the Blessed Virgin Mary, Castel Gandolfo, August 15, 2013

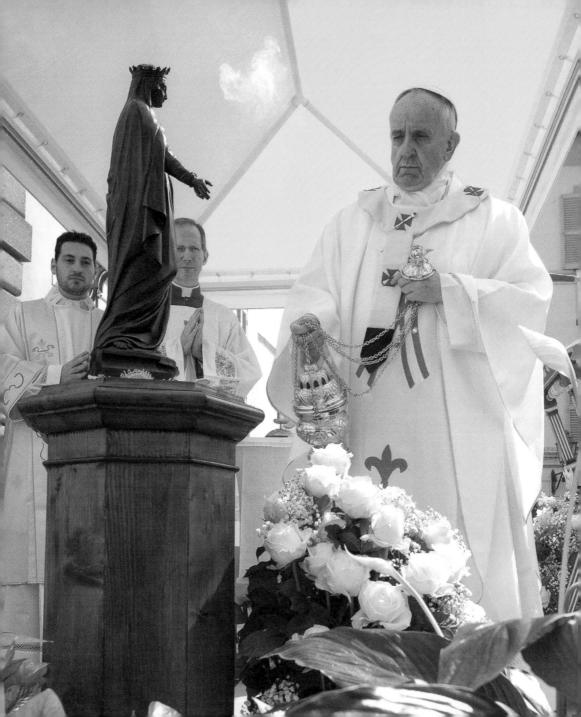

Magnificat

Mary says: "My soul glorifies the Lord"—today, the Church too sings this in every part of the world. This song is particularly strong in places where the Body of Christ is suffering the Passion. For us Christians, wherever the Cross is, there is hope, always. If there is no hope, we are not Christian. That is why I like to say: do not allow yourselves to be robbed of hope. May we not be robbed of hope, because this strength is a grace, a gift from God, which carries us forward with our eyes fixed on Heaven. And Mary is always there, near those communities, our brothers and sisters; she accompanies them, suffers with them, and sings the *Magnificat* of hope with them.

Homily on the Solemnity of the Assumption
of the Blessed Virgin Mary, Castel Gandolfo, August 15, 2013

Heaven

Mary, Mother of God, pray for us sinners, and guide us on the way that leads to Heaven.

Tweet, August 15, 2013

Task

Let us ask Mary to help us fix our eyes intently on Jesus, to follow him always, even when this is demanding.

Tweet, August 31, 2013

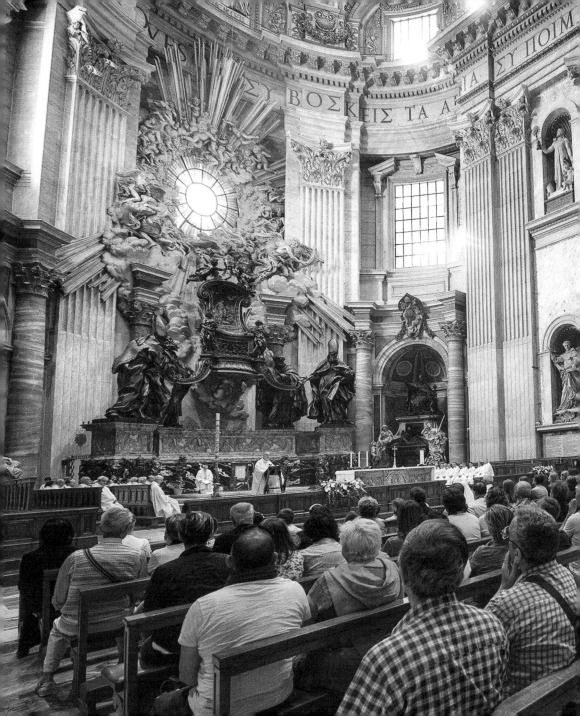

Peace

Is it possible to walk the path of peace? Can we get out of this spiral of sorrow and death? Can we learn once again to walk and live in the ways of peace? Invoking the help of God, under the maternal gaze of the *Salus Populi Romani*, Queen of Peace, I say: Yes, it is possible for everyone!

Vigil of Prayer for Peace, September 7, 2013

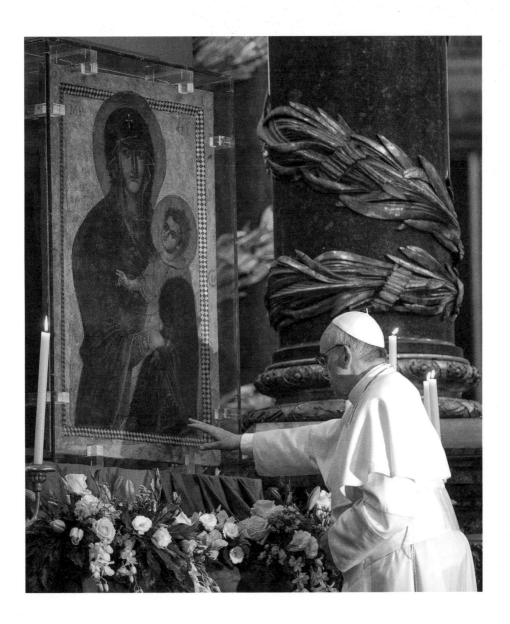

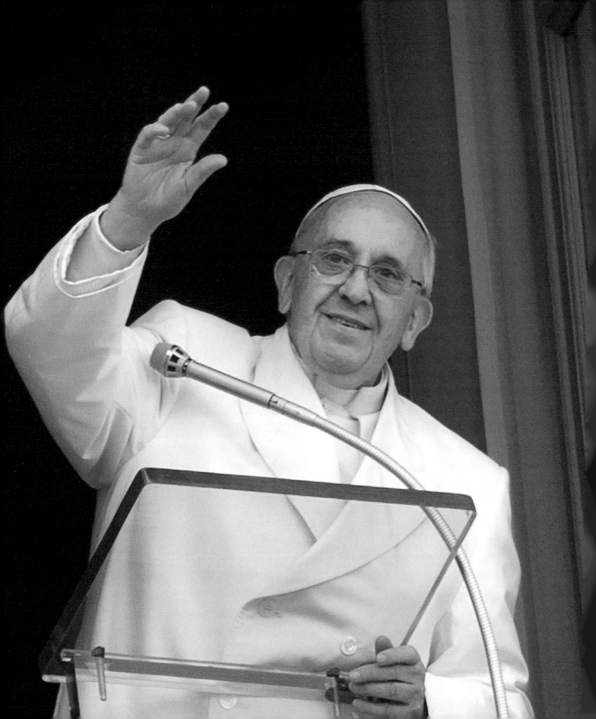

Dawn

Jesus is the sun; Mary is the dawn that heralds his rising. […] Queen of Peace pray for us!

<div align="right">

Angelus, *September 8, 2013*

</div>

Sweetness

Let us entrust ourselves to Our Lady. And when today we give her our best wishes on her feast day, let us ask her that she ask for the grace for us to experience her sweetness.

Homily in the Chapel of the Domus Sanctae Marthae, September 12, 2013

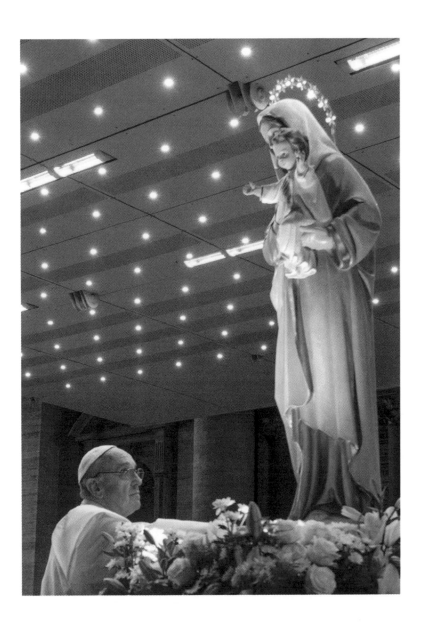

Longing

Here you bring the joys and sufferings of this land, of your families, and even of those of its children who live far away, who have left with great pain and longing in order to find work and a future for themselves and for those who are dear to them. Today, we who gather here want to thank Mary, because she is always near to us. We want to renew our trust and our love for her.

Homily of the Mass at the Shrine of Our Lady of Bonaria (Cagliari), September 22, 2013

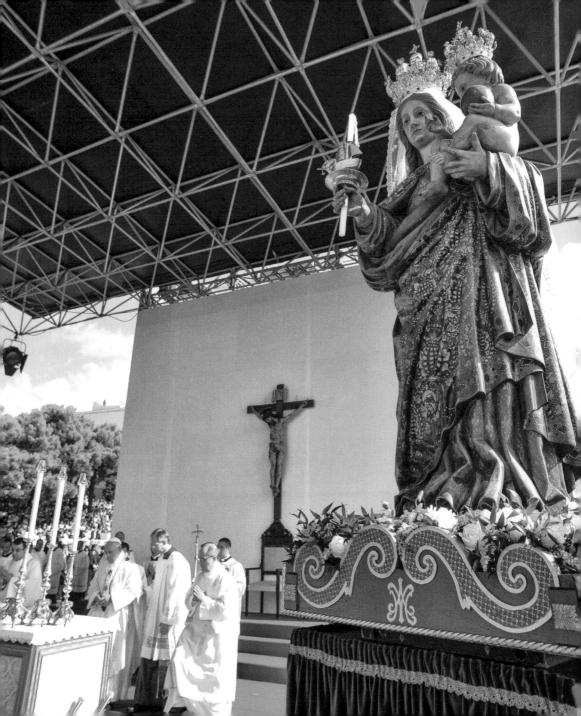

Gaze

We have come together to encounter the gaze of Mary, which reflects the gaze of the Father, who made her the Mother of God, and the gaze of the Son on the Cross, who made her our Mother. It is with that gaze that Mary watches us today. We need her tender gaze, her maternal gaze, which knows us better than anyone else, her gaze full of compassion and care. Mary, today we want to tell you: Mother grant us your gaze! Your gaze leads us to God, your gaze is a gift of the good Father who waits for us at every turn of our path, it is a gift of Jesus Christ on the Cross, who takes upon himself our sufferings, our struggles, our sin.

Homily of the Mass at the Shrine
of Our Lady of Bonaria (Cagliari), September 22, 2013

Brothers

The gaze of Our Lady helps us to look at one another as brothers and sisters. Let us look upon one another in a more fraternal way! Mary teaches us to have that gaze which strives to welcome, to accompany and to protect. Let us learn to look at one another beneath Mary's maternal gaze! There are people whom we instinctively consider less and who instead are in greater need: the most abandoned, the sick, those who have nothing to live on, those who do not know Jesus, youth who find themselves in difficulty, young people who cannot find work. Let us not be afraid to go out and to look upon our brothers and sisters with Our Lady's gaze. She invites us to be true brothers and sisters.

Homily of the Mass at the Shrine
of Our Lady of Bonaria (Cagliari), September 22, 2013

Fearfulness

Nearest to Jesus, on the Cross, was His mother—His dear mother. Perhaps today, this day in which we pray to her, it would be good to ask her not for the grace to take away our fear—that must come, that fear of the Cross... But the grace we need not to fly from the Cross in fear. She was there and she knows how to be near the Cross.

Homily in the Chapel of the Domus Sanctae Marthae, September 28, 2013

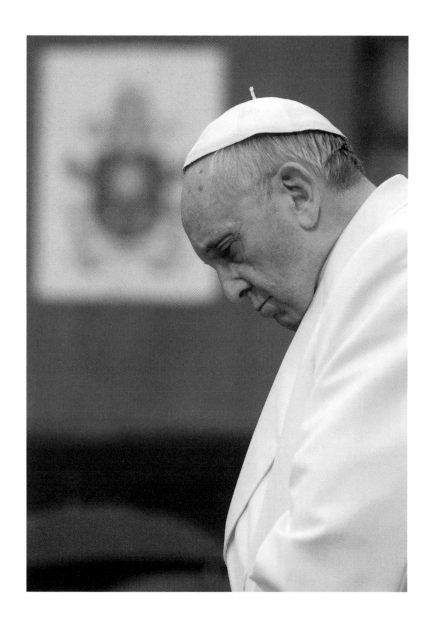

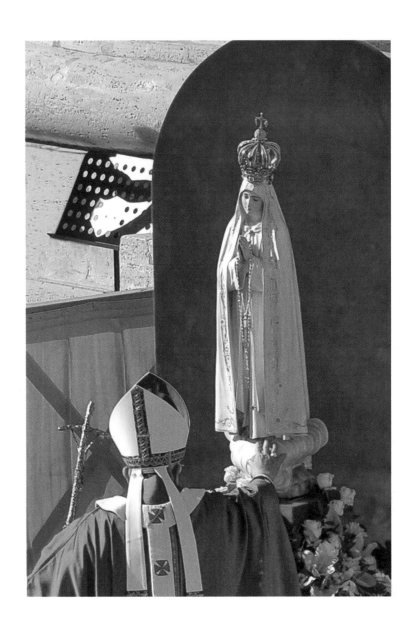

Embrace

When we encounter the Cross, we turn to Mary: Give us the strength, Mary our Mother, to accept and embrace the Cross!

Tweet, October 11, 2013

Knots

Mary, whose "yes" opened the door for God to undo the knot of ancient disobedience, is the Mother who patiently and lovingly brings us to God, so that he can untangle the knots of our soul by his fatherly mercy. [...] She leads us by the hand as a Mother, our Mother, to the embrace of our Father, the Father of mercies.

Marian Prayer in St. Peter's Square, October 12, 2013

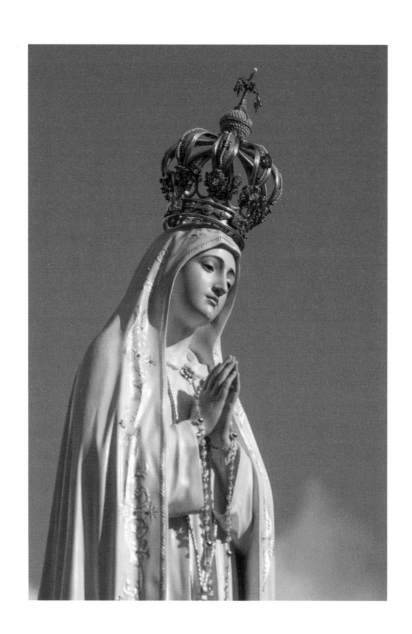

Freedom

God did not want to become man by bypassing our freedom; he wanted to pass through Mary's free assent, through her "yes." He asked her: "Are you prepared to do this?" And she replied: "Yes."

Marian Prayer in St. Peter's Square, October 12, 2013

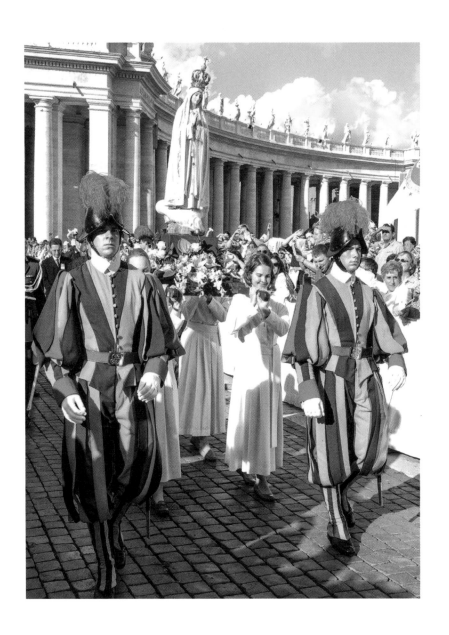

Journey

How was Mary's faith a journey? In the sense that her entire life was to follow her Son: he—Jesus—is the way, he is the path! To press forward in faith, to advance in the spiritual pilgrimage which is faith, is nothing other than to follow Jesus; to listen to him and be guided by his words; to see how he acts and to follow in his footsteps; to have his same sentiments.

Marian Prayer in St. Peter's Square, October 12, 2013

Cross

The journey of faith thus passes through the cross. Mary understood this from the beginning, when Herod sought to kill the newborn Jesus. But then this experience of the Cross became deeper when Jesus was rejected. Mary was always with Jesus, she followed Jesus in the midst of the crowds and she heard all the gossip and the nastiness of those who opposed the Lord. And she carried this Cross! [...] Through the night of Holy Saturday, Mary kept watch. Her flame, small but bright, remained burning until the dawn of the Resurrection. And when she received word that the tomb was empty, her heart was filled with the joy of faith.

Marian Prayer in St. Peter's Square, October 12, 2013

JOY

Faith always brings us to joy, and Mary is the Mother of joy! May she teach us to take the path of joy, to experience this joy! [...] What is our faith like? Like Mary, do we keep it burning even at times of difficulty, in moments of darkness? Do I feel the joy of faith?

Marian Prayer in St. Peter's Square, October 12, 2013

Love

At whom is the Virgin Mary looking? She is looking at each and every one of us. And how does she look at us? She looks at us as a Mother, with tenderness, mercy, and love. That was how she gazed at her Son Jesus during all the moments of his life—joyful, luminous, sorrowful, glorious—as we contemplate the mysteries of the Holy Rosary, simply and lovingly.

Video Message on the occasion of the Prayer Vigil
at the Shrine of Divine Love in Rome, October 12, 2013

Difficulties

When we are weary, downcast, beset with cares, let us look to Mary, let us feel her gaze, which speaks to our heart and says: "Courage, my child, I am here to help you!" Our Lady knows us well, she is a Mother, she is familiar with our joys and difficulties, our hopes and disappointments. When we feel the burden of our failings and our sins, let us look to Mary, who speaks to our hearts, saying: "Arise, go to my Son Jesus; in him you will find acceptance, mercy, and new strength for the journey."

Video Message on the occasion of the Prayer Vigil
at the Shrine of Divine Love in Rome, October 12, 2013

Astonishment

This was the experience of the Virgin Mary: At the message of the angel, she did not hide her surprise. It was the astonishment of realizing that God, to become man, had chosen her, a simple maid of Nazareth—not someone who lived in a palace amid power and riches, or one who had done extraordinary things, but simply someone who was open to God and put her trust in him, even without understanding everything.

Homily of the Mass for the "Marian Day"
on the Occasion of the Year of Faith, October 13, 2013

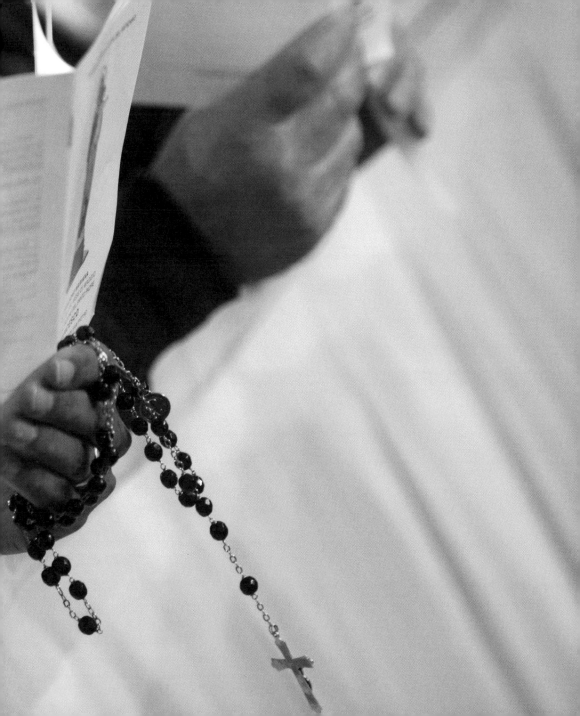

Gift

Take Mary: After the Annunciation, her first act was one of charity toward her elderly kinswoman Elizabeth. Her first words were: "My soul magnifies the Lord," in other words, a song of praise and thanksgiving to God not only for what he did for her, but for what he had done throughout the history of salvation. Everything is his gift. If we can realize that everything is God's gift, how happy will our hearts be!

Homily of the Mass for the "Marian Day"
on the Occasion of the Year of Faith, October 13, 2013

Smile

Blessed Virgin Mary of Fatima, with renewed gratitude for your motherly presence we join in the voice of all generations that call you blessed. We celebrate in you the great works of God, who never tires of lowering himself in mercy over humanity, afflicted by evil and wounded by sin, to heal and to save it. […] We are certain that each one of us is precious in your eyes and that nothing in our hearts has estranged you. May we allow your sweet gaze and the perpetual warmth of your smile to reach us.

Act of Entrustment to the Blessed Virgin Mary of Fatima, October 13, 2013

Holiness

Guard our lives with your embrace: bless and strengthen every desire for good; give new life and nourishment to faith; sustain and illuminate hope; inspire and activate charity; guide us all on the path to holiness. Teach us your own special love for the little ones and for the poor, for the excluded and the suffering, for sinners and the wounded of heart: gather all people under your protection and give us all to your beloved Son, our Lord Jesus.

Act of Entrustment to the Blessed Virgin Mary of Fatima, October 13, 2013

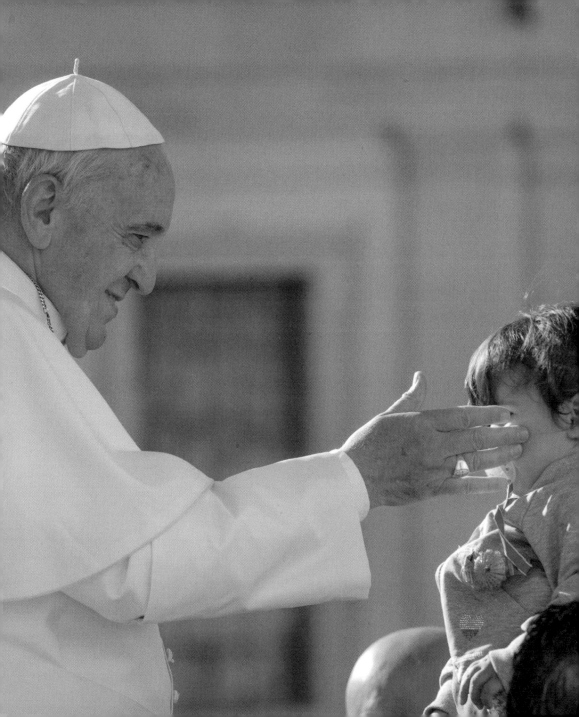

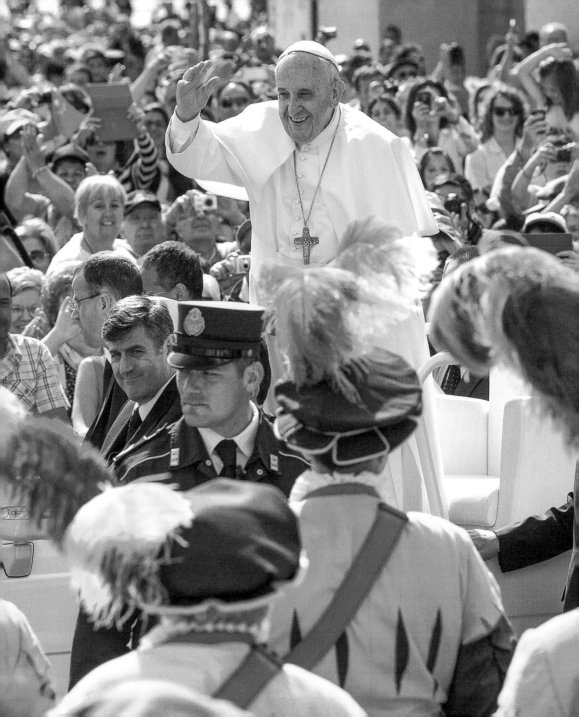

Generations

Mary and Joseph are the family, sanctified by the presence of Jesus who is the fulfillment of all God's promises. Like the Holy Family of Nazareth, every family is part of the history of a people; it cannot exist without the generations who have gone before it.

*Meeting with the Families of the World
in the Pilgrimage for the Year of Faith, October 26, 2013*

Family

We invoke the maternal protection of Mary for families all around the world, particularly for those who live in situations of great difficulty. Mary, Queen of the Family, pray for us!

Angelus, *October 27, 2013*

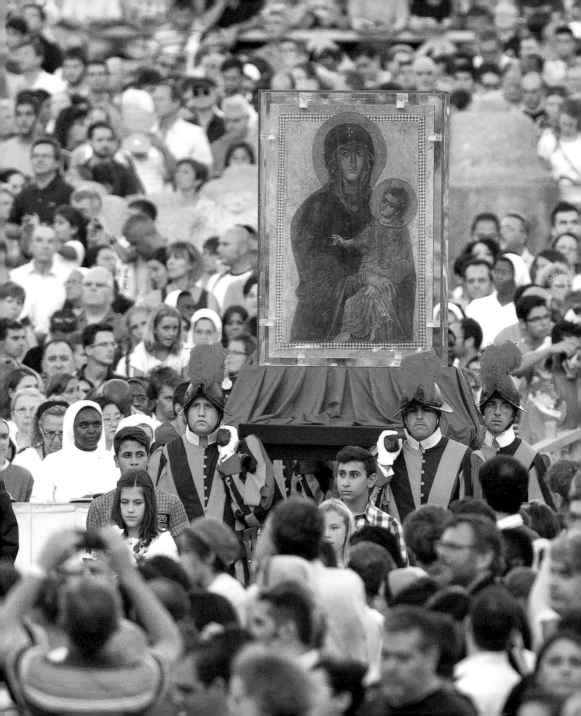

Care

Imitate Mary's motherhood, the maternal care that she has for each one of us. During the miracle at the Wedding at Cana, our Lady turned to the servants and said to them: "Do whatever he tells you." Jesus ordered the servants to fill the jars with water and the water became wine, better wine than that which had been served before [...] Mary knows what we need! She takes care of us, interceding with Jesus [...] She is always interceding and praying for us, especially in the hour of difficulty and weakness, in the hour of distress and confusion, and especially in the hour of sin. That is why, in the prayer of the Hail Mary, we ask her: "Pray for us sinners."

To Participants in the Pilgrimage of Unitalsi, November 9, 2013

Hope

Mary is the Mother of hope, the icon that most fully expresses Christian hope. Her whole life is a series of episodes of hope, beginning with her "yes" at the moment of the Annunciation. Mary did not know how she could become a mother, but she entrusted herself totally to the mystery that was about to be fulfilled, and she became the woman of expectation and of hope. […] the Virgin's hope is never shaken!

Visit to the Monastery of St. Anthony the Abbot of the Camaldolese Benedictine Nuns on the Aventine Hill, November 21, 2013

Expectation

With the start of his public ministry, Jesus becomes the Teacher and the Messiah: Our Lady looks upon the mission of the Son with joy but also with apprehension. [...] At the foot of the Cross, she is at once the woman of sorrow and of watchful expectation of a mystery far greater than sorrow, which is about to be fulfilled.

Visit to the Monastery of St. Anthony the Abbot of the Camaldolese
Benedictine Nuns on the Aventine Hill, November 21, 2013

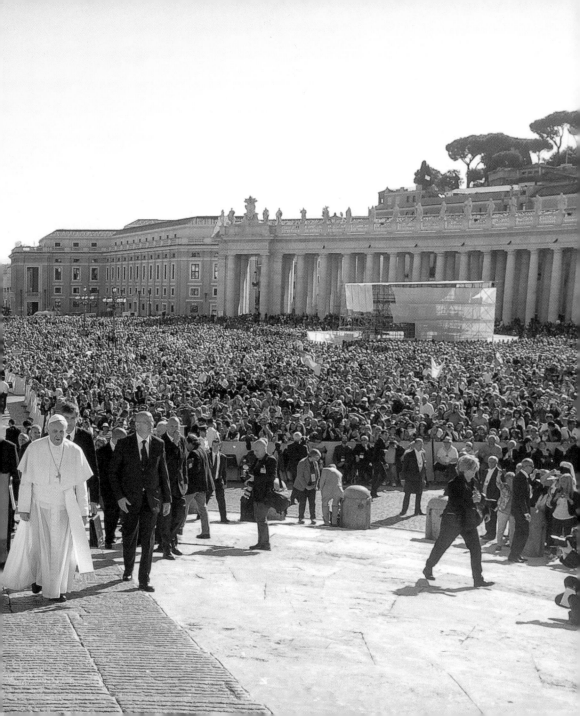

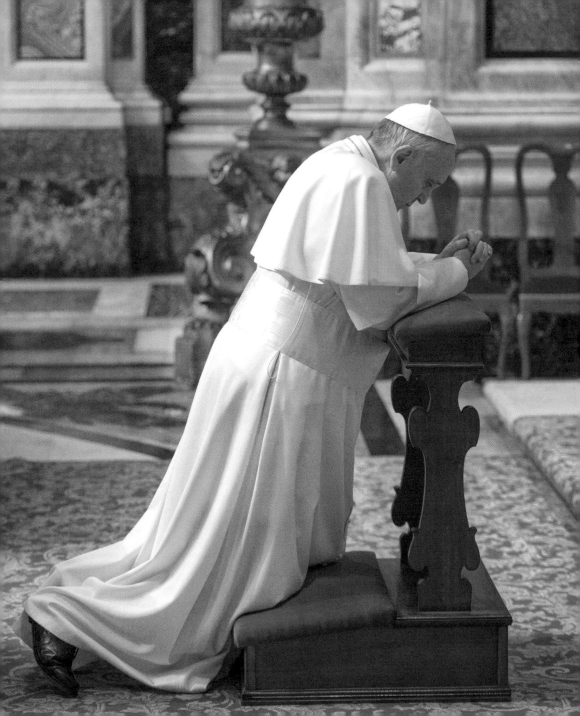

Support

We owe so much to this Mother! She has been present at every
moment in the history of salvation, and in her we see a firm witness
to hope. She, the Mother of hope, sustains us in times of darkness,
difficulty, discouragement, of apparent defeat or true human defeat.
May Mary, our hope, help us to make of our lives a pleasing offering
to the Heavenly Father, and a joyful gift for our brothers and sisters,
in an attitude that always looks forward to tomorrow.

Visit to the Monastery of St. Anthony the Abbot of the Camaldolese
Benedictine Nuns on the Aventine Hill, November 21, 2013

Pentecost

With the Holy Spirit, Mary is always present in the midst of the people. She joined the disciples in praying for the coming of the Holy Spirit (*Acts* 1:14) and thus made possible the missionary outpouring which took place at Pentecost. She is the Mother of the Church, which evangelizes, and without her we could never truly understand the spirit of the new evangelization.

Apostolic Exhortation Evangelii Gaudium, *November 24, 2013*

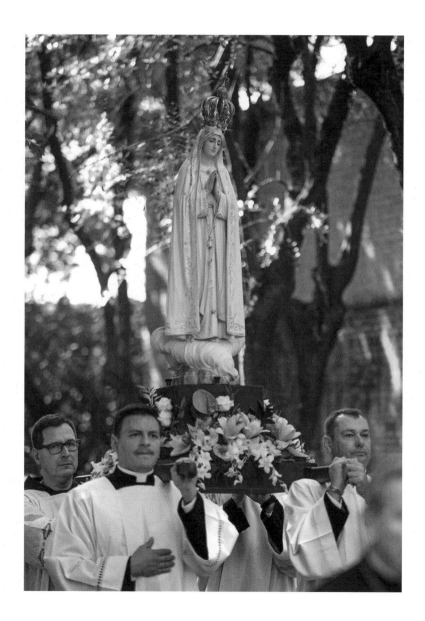

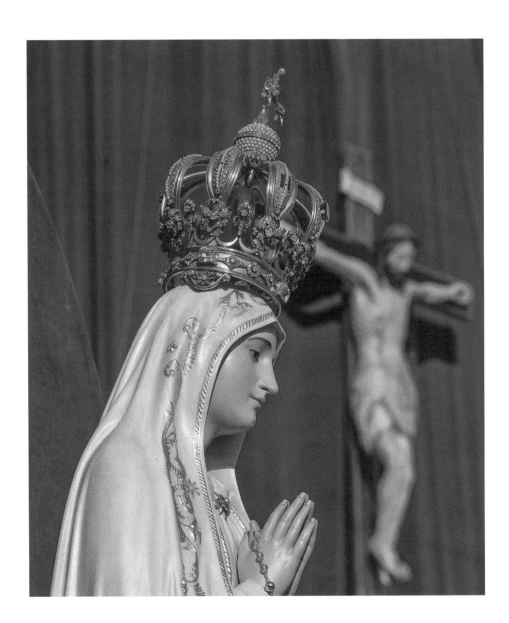

The Supreme Hour

Jesus left us his Mother to be our Mother. Only after doing so did Jesus know that "all was now finished" (*Jn* 19:28). At the foot of the Cross, at the supreme hour of the new creation, Christ led us to Mary. He brought us to her because he did not want us to journey without a mother, and our people read in this maternal image all the mysteries of the Gospel.

Apostolic Exhortation Evangelii Gaudium, *November 24, 2013*

Praise

Mary was able to turn a stable into a home for Jesus, with poor swaddling clothes and an abundance of love. She is the handmaid of the Father who sings his praises. She is the friend who is always concerned that wine is not lacking in our lives. She is the woman whose heart was pierced by a sword and who understands all of our pain.

Apostolic Exhortation Evangelii Gaudium, *November 24, 2013*

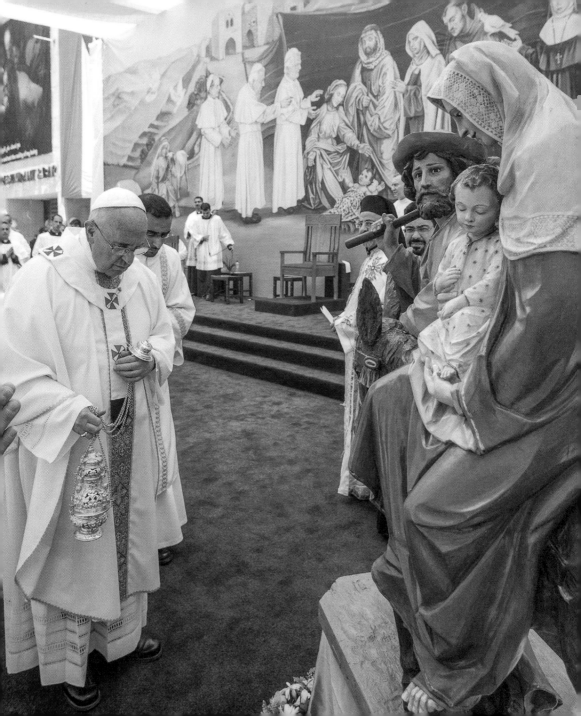

Justice

As mother of all, she is a sign of hope for people suffering the birth pangs of justice. She is the missionary who draws near to us and accompanies us throughout life, opening our hearts to faith through her maternal love. As a true mother, she walks at our side, she shares our struggles and she constantly surrounds us with God's love. Through her many titles, often linked to her shrines, Mary shares the history of each person who has received the Gospel and thus becomes a part of their historic identity.

Apostolic Exhortation Evangelii Gaudium, *November 24, 2013*

Shrines

Many Christian parents ask that their children be baptized in a Marian shrine, as a sign of their faith in her motherhood, which brings forth new children for God. It is in these many shrines that we can see how Mary brings together her children, who with great effort come as pilgrims to see her and to be seen by her. Here they find strength from God to bear the weariness and the suffering in their lives.

Apostolic Exhortation Evangelii Gaudium, *November 24, 2013*

Service

Mary let herself be guided by the Holy Spirit on a journey of faith toward a destiny of service and fruitfulness. Today we look to her and ask her to help us proclaim the message of salvation to all and to enable new disciples to become evangelizers in turn. Along this journey of evangelization we will have our moments of hardship, darkness, and even fatigue. Mary herself experienced these things during the years of Jesus' childhood in Nazareth.

Apostolic Exhortation Evangelii Gaudium, *November 24, 2013*

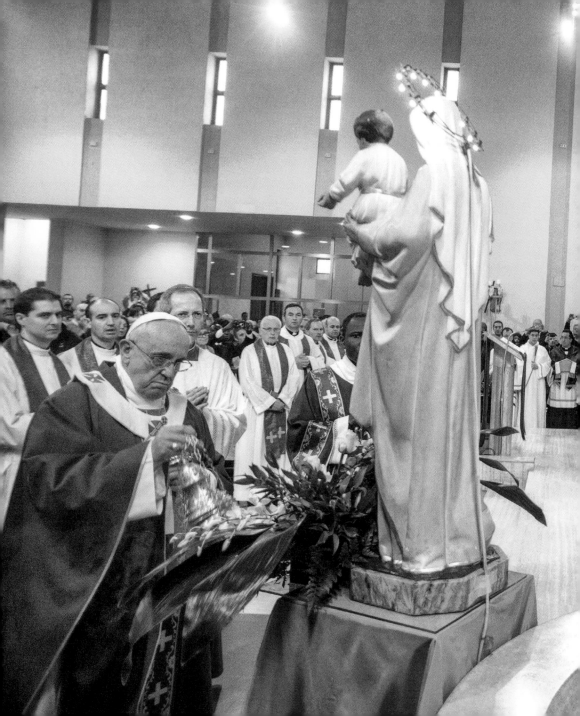

Affection

There is a Marian "style" to the Church's work of evangelization. Whenever we look to Mary, we come to believe once again in the revolutionary nature of love and tenderness. In her we see that humility and tenderness are not virtues of the weak but of the strong who need not treat others poorly in order to feel important themselves.

Apostolic Exhortation Evangelii Gaudium, *November 24, 2013*

A New World

We implore her maternal intercession that the Church may become a home for many, a mother for all people, and that the way may be opened for the birth of a new world.

Apostolic Exhortation Evangelii Gaudium, *November 24, 2013*

Guide

A simple girl from the country, who carries within her heart the fullness of hope in God! In her womb, God's hope took flesh, it became man and became history: Jesus Christ. Her *Magnificat* is the canticle of the People of God on a journey, and of all men and women who hope in God and in the power of his mercy. Let us allow ourselves to be guided by her, she who is Mother, a mom, and knows how to guide us. Let us allow ourselves to be guided by her during this season of active waiting and watchfulness.

Angelus, *December 1, 2013*

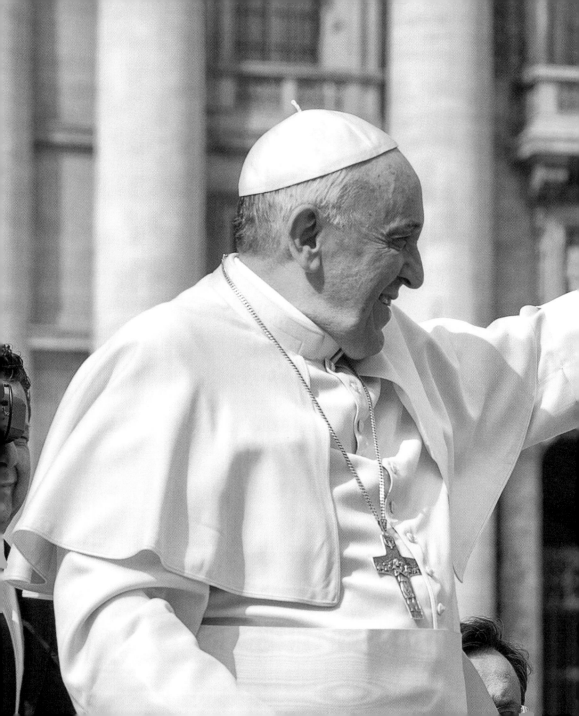

Beauty

Our gaze is drawn to the beauty of the Mother of Jesus, our Mother!
With great joy the Church contemplates her "full of grace." [...] This
is how God saw her from the first moment of his loving design. He
saw her as beautiful, full of grace. Our Mother is beautiful!

Angelus, *December 8, 2013*

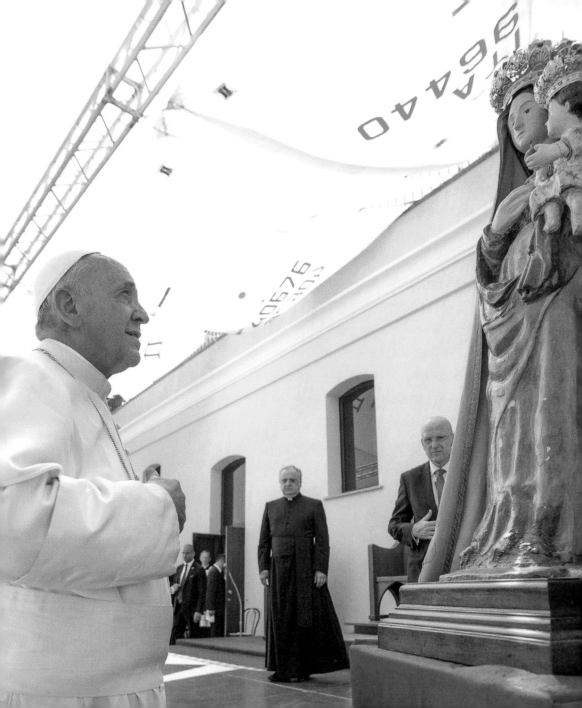

Immaculate Conception

Yet the Lord's gaze rested on her, on this little girl from a distant village, on the one he had chosen to be the mother of his Son. In view of this motherhood, Mary was preserved from original sin, from that fracture in communion with God, with others and with creation, which deeply wounds every human being. But this fracture was healed in advance in the Mother of the One who came to free us from the slavery of sin. The *Immaculata* was written in God's design; she is the fruit of God's love that saves the world.

Angelus, *December 8, 2013*

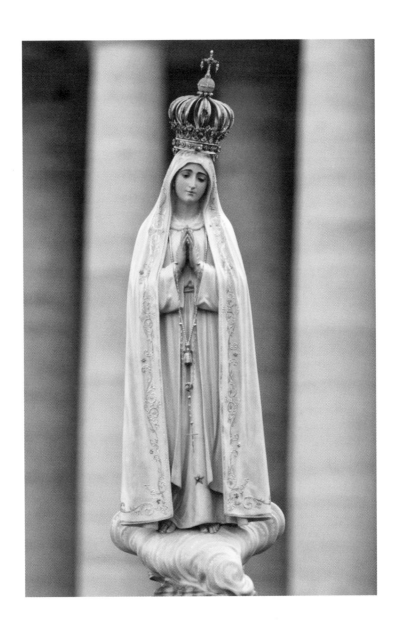

Mystery

The mystery of this girl from Nazareth, who is in the heart of God, is not a stranger. She is not over there while we are over here. No, we are connected. Indeed, God rests his loving gaze on every man and every woman! By name and surname. His gaze of love is on each one of us. The Apostle Paul states that God "chose us in him before the foundation of the world, that we should be holy and blameless before him." [...] We too, were chosen by God to live a holy life, free of sin. It is a plan of love that God renews every time we come to him, especially through the Sacraments.

Angelus, *December 8, 2013*

Destiny

By contemplating our beautiful Immaculate Mother, let us also recognize our truest destiny, our deepest vocation: to be loved, to be transformed by love, to be transformed by the beauty of God. Let us look to her, our Mother, and allow her to look upon us, for she is our Mother and she loves us so much; let us allow ourselves to be watched over by her so that we may learn how to be more humble, and also more courageous in following the Word of God; to welcome the tender embrace of her Son Jesus, an embrace that gives us life, hope, and peace.

Angelus, *December 8, 2013*

Steps

You are all-beautiful, O Mary! In you is the fullness of joy born of life with God. Help us never to forget the meaning of our earthly journey: May the kindly light of faith illuminate our days, the comforting power of hope direct our steps, the contagious warmth of love stir our hearts; and may our gaze be fixed on God, in whom true joy is found.

Act of Veneration to the Immaculate at the Spanish Steps, December 8, 2013

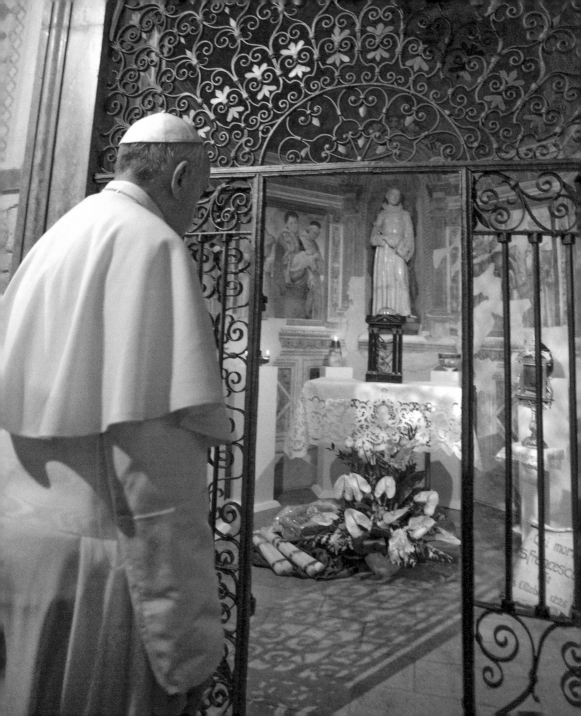

Darkness

Mary, Our Mother, sustain us in moments of darkness, difficulty, and apparent defeat.

Tweet, December 10, 2013

Miracle

May the Virgin Mary help us to hasten our steps to Bethlehem, to encounter the Child who was born for us, for the salvation and joy of all people. […] May she obtain for us the grace to live the joy of the Gospel in our families, at work, in the parish, and everywhere. It is an intimate joy, made of wonder and tenderness; it is the joy a mother experiences when she looks at her newborn baby and feels that he or she is a gift from God, a miracle for which she can only give thanks!

Angelus, *December 15, 2013*

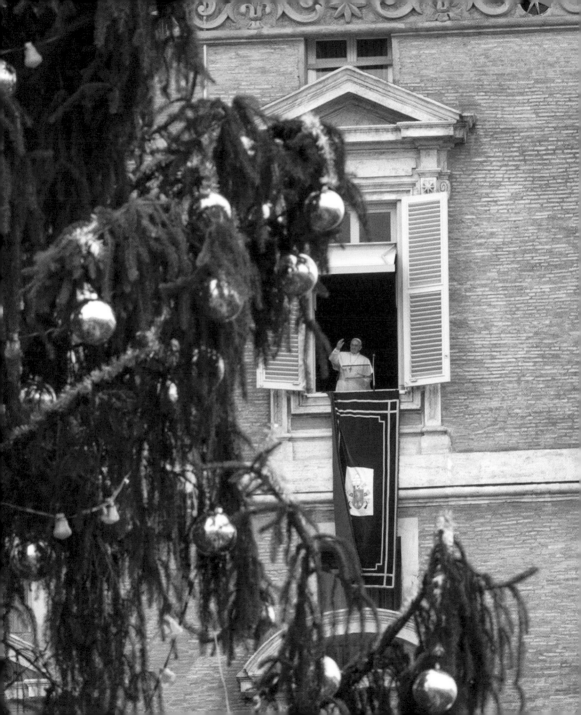

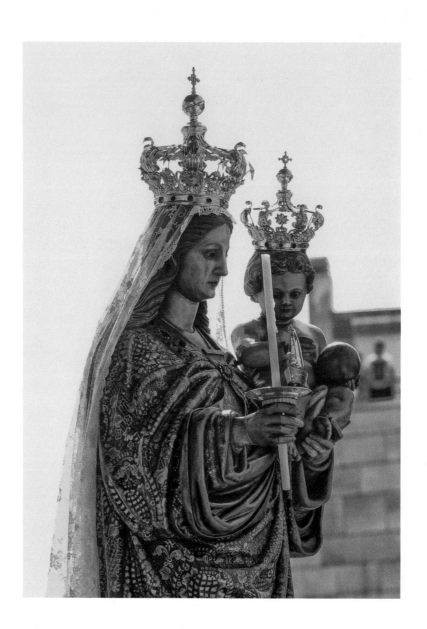

Silence

I think about how many times she remained silent, how many times she did not say what she felt in order to guard the mystery of her relationship with her Son. [...] Silence guards the mystery. [...] Mary was silent, but within her heart how many things she said to the Lord!

Homily in the Chapel of the Domus Sanctae Marthae, December 20, 2013

Concern

Let us feel close to one another on this final stretch of the road to Bethlehem. We would do well to meditate on Saint Joseph, who was so silent yet so necessary at the side of Our Lady. Let us think about him and his loving concern for his spouse and for the baby Jesus. This can tell us a lot about our own service to the Church!

Address to the Roman Curia on the Occasion of the Presentation of the Christmas Greetings, December 21, 2013

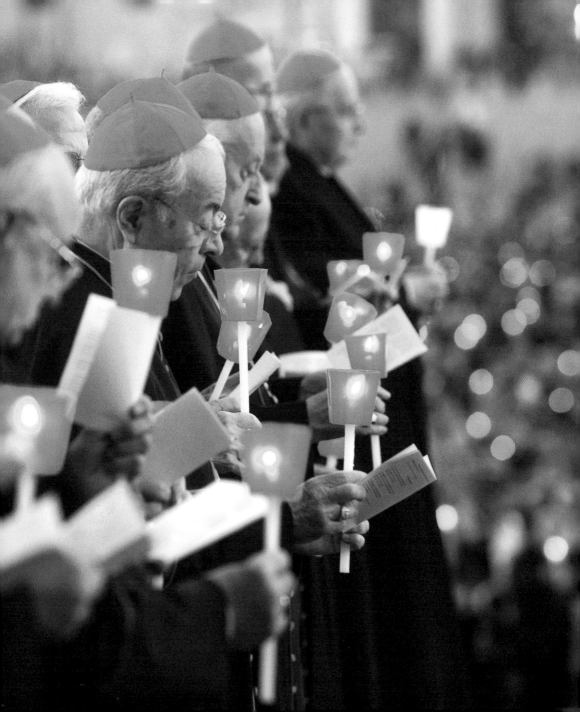

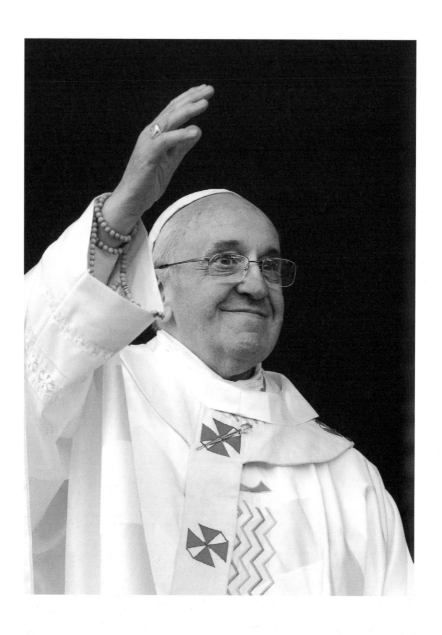

Courage

Mary is the woman full of grace who had the courage to entrust herself totally to the Word of God.

Angelus, *December 22, 2013*

Soul

Are our souls open, as the soul of the Holy Mother Church is open, and as Mary's soul was open? Or have we closed our souls and put a polite note on the door saying: please do not disturb?

Homily in the Chapel of the Domus Sanctae Marthae, December 23, 2013

Light

The grace which has been revealed in our world is Jesus, born of the Virgin Mary, true man and true God. He has entered our history; he has shared our journey. He came to free us from darkness and to grant us light. In him was revealed the grace, the mercy, and the tender love of the Father: Jesus is Love incarnate.

Homily of the Midnight Mass on the Solemnity
of the Nativity of the Lord, December 24, 2013

Fulfillment

Our Mother Mary is full of beauty because she is full of grace.

Tweet, December 28, 2013

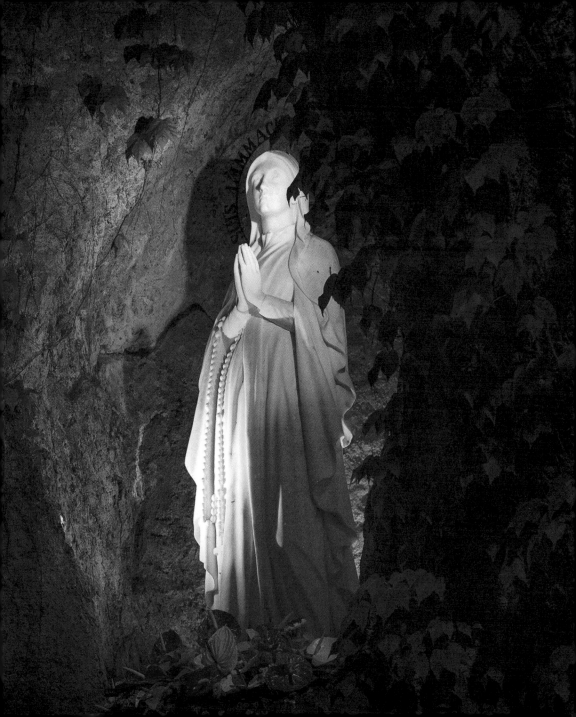

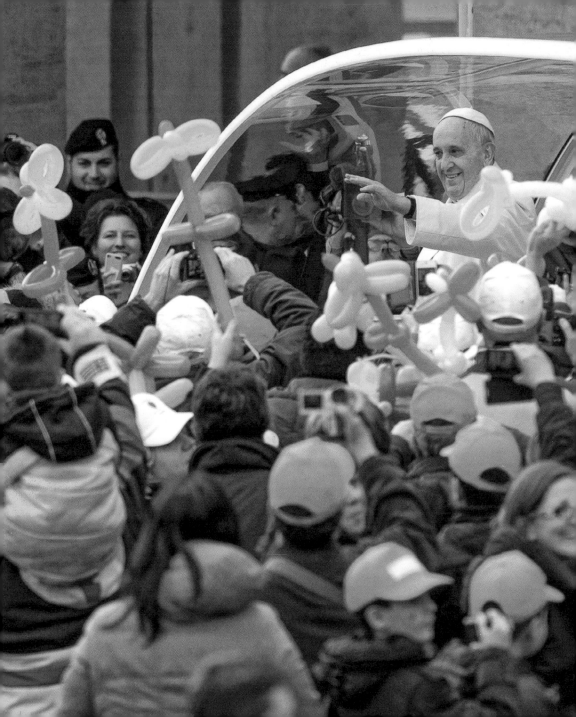

Welcome

May the Mother of God [...] teach us to welcome God made man, so that every year, every month, every day may be filled with his eternal Love.

Celebration of First Vespers of the Solemnity of Mary Most Holy, Mother of God, and Te Deum *of Thanksgiving for the End of the Year, December 31, 2013*

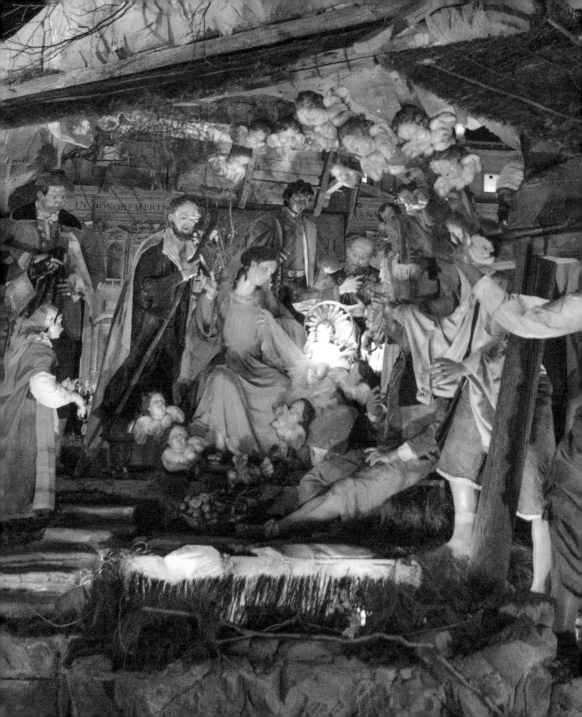

Cradle

Let us draw from the cradle the joy and deep peace that Jesus brings to the world.

Tweet, December 31, 2013

Mother

The Mother of God: This is the first and most important title of Our Lady. It refers to a quality, a role which the faith of the Christian people, in its tender and genuine devotion to our heavenly Mother, has understood from the beginning. […] Our pilgrimage of faith has been inseparably linked to Mary ever since Jesus, dying on the Cross, gave her to us as our Mother.

Homily of the Mass on the Solemnity of Mary Most Holy,
Mother of God, XLVII World Day of Peace, January 1, 2014

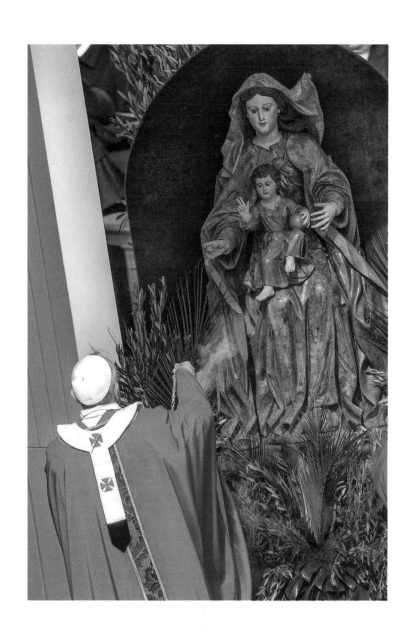

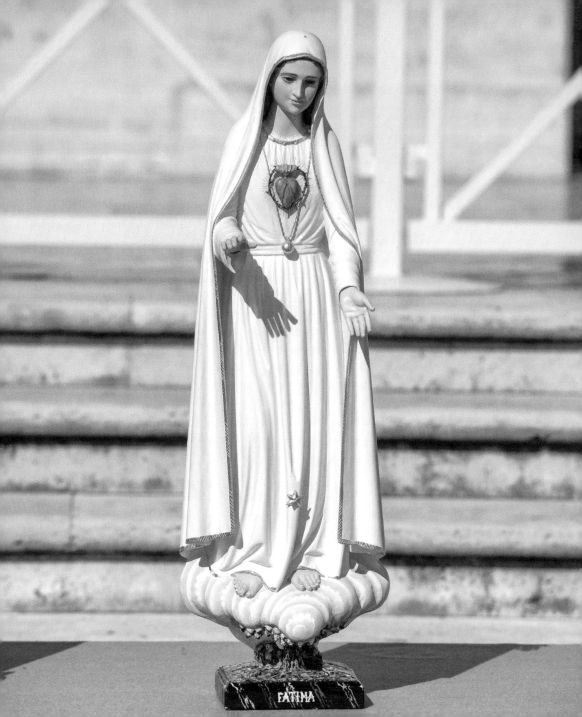

Heart

When the faith of the disciples was most tested by difficulty and uncertainty, Jesus entrusted them to Mary, who was the first to believe, and whose faith would never fail. [...] Her sorrowful heart was enlarged to make room for all men and women, whether good or bad, and she loved them as she loved Jesus.

Homily of the Mass on the Solemnity of Mary Most Holy,
Mother of God, XLVII World Day of Peace, January 1, 2014

Humility

The Mother of the Redeemer goes before us and continually strengthens us in faith, in our vocation and in our mission. By her example of humility and openness to God's will she helps us to transmit our faith in a joyful proclamation of the Gospel to all, without reservation. In this way our mission will be fruitful, because it is modeled on the motherhood of Mary. To her let us entrust our journey of faith, the desires of our heart, our needs and the needs of the whole world, especially of those who hunger and thirst for justice and peace, and for God.

Homily of the Mass on the Solemnity of Mary Most Holy,
Mother of God, XLVII World Day of Peace, January 1, 2014

Cry for Peace

With filial trust, let us place our hopes in the hands of Mary, the Mother of the Redeemer. To she who extends her motherhood to all mankind, let us entrust the cry for peace of peoples who are oppressed by war and violence, so that the courage of dialogue and reconciliation might prevail over temptation for revenge, terrorism, and corruption. Let us ask her to grant that the Gospel of fraternity, which the Church proclaims and to which she bears witness, may speak to every conscience and bring down the walls that prevent enemies from recognizing one another as brothers.

Angelus, *January 1, 2014*

Littleness

May the Lord grant us, through the intercession of Our Lady—who joyfully sang to God, for he had looked upon her lowliness—the grace to keep watch over our littleness in his sight.

Homily in the Chapel of the Domus Sanctae Marthae, January 21, 2014

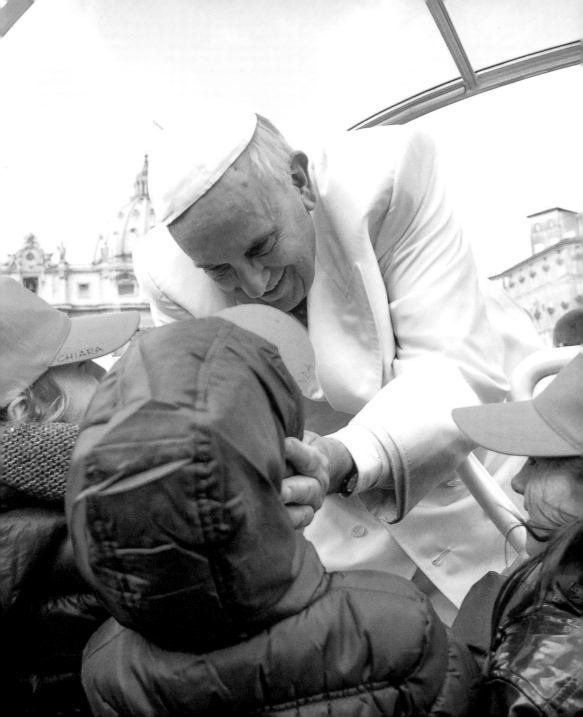

Genius

Let us think of Our Lady: Our Lady creates something in the Church that priests, bishops and Popes cannot create. She is the true feminine genius. Let us also think about Our Lady in terms of families—about what Our Lady does in a family.

Address to Participants in the National Congress
sponsored by the Italian Women's Center, January 25, 2014

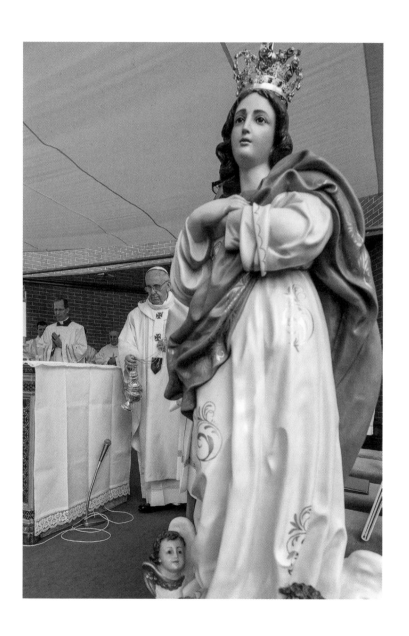

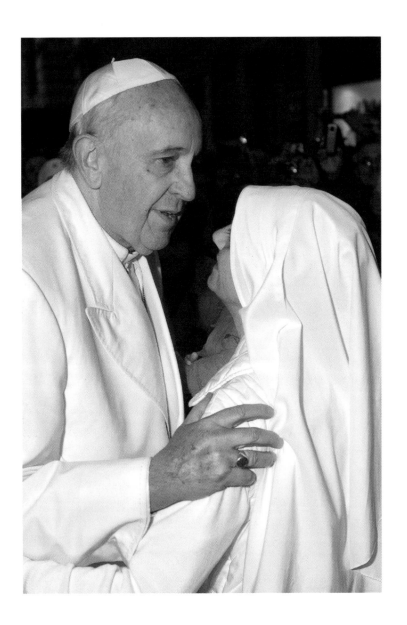

Consecrated Life

Let us look at consecrated life as an encounter with Christ: it is he who comes to us, led by Mary and Joseph, and we go toward Him guided by the Holy Spirit.

Homily of the Mass Celebrated for the Day of Consecrated Life, February 2, 2014

Beatitudes

Dear friends, the *Magnificat*, the Canticle of Mary, poor in spirit, is also the song of everyone who lives by the Beatitudes. The joy of the Gospel arises from a heart which, in its poverty, rejoices and marvels at the works of God, like the heart of Our Lady, whom all generations call "blessed." […] May Mary, Mother of the poor and star of the new evangelization help us to live the Gospel, to embody the Beatitudes in our lives, and to have the courage always to be happy.

Message for the XXIX World Youth Day, February 6, 2014

Closeness

Our Lady is always close to us, especially when we feel the weight of life with all of its problems.

Tweet, February 24, 2014

Sobriety

Let us invoke the Virgin Mary as Mother of Divine Providence. To her we entrust our lives, the journey of the Church and all humanity. In particular, let us invoke her intercession that we may all strive to live in a simple and sober manner, keeping in mind the needs of those brothers who are most in need.

Angelus, *March 2, 2014*

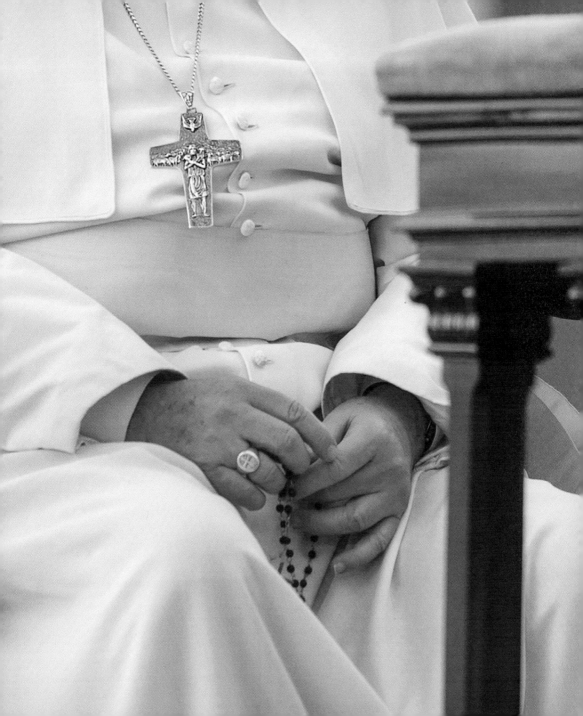

Salvation

Salvation cannot be bought and sold; it is given as a gift, it is free. We cannot save ourselves, salvation is a totally free gift. [...] In order for this salvation to enter into us we need a humble heart, a docile heart, an obedient heart like Mary's.

Homily in the Chapel of the Domus Sanctae Marthae, March 25, 2014

Easter

Having passed through the experience of the death and Resurrection of her Son, seen in faith as the supreme expression of God's love, Mary's heart has become a font of peace, consolation, hope, and mercy. All of the prerogatives of our Mother come from this, from her participation in Jesus' Paschal mystery. From Friday until Sunday morning she did not lose hope: we contemplated the sorrowful Mother but, at the same time, the Mother full of hope. She, who is the Mother of all of the disciples, the Mother of the Church, is the Mother of hope.

Regina Coeli, *April 21, 2014*

Companionship

Our Lady always followed Jesus; to the end she accompanied him. Let us pray to her that she may always accompany us on our path: this path of joy, this path of continuing, this journey of staying with Jesus.

Address to the Italian Catholic Action, May 3, 2014

Counsel

I remember once at the Shrine of Luján I was in the confessional, where there was a long queue. There was a very modern young man, with earrings, tattoos, all these things. … and he came to tell me what was happening to him. It was a big and difficult problem. And he said to me: "I told my mother all of this and my mother said to me, go to Our Lady and she will tell you what you must do." Here is a woman who had the gift of counsel. She did not know how to help her son out of his problem, but she indicated the right road: go to Our Lady and she will tell you. This is the gift of counsel. That humble, simple woman, gave her son the truest counsel.

General Audience, May 7, 2014

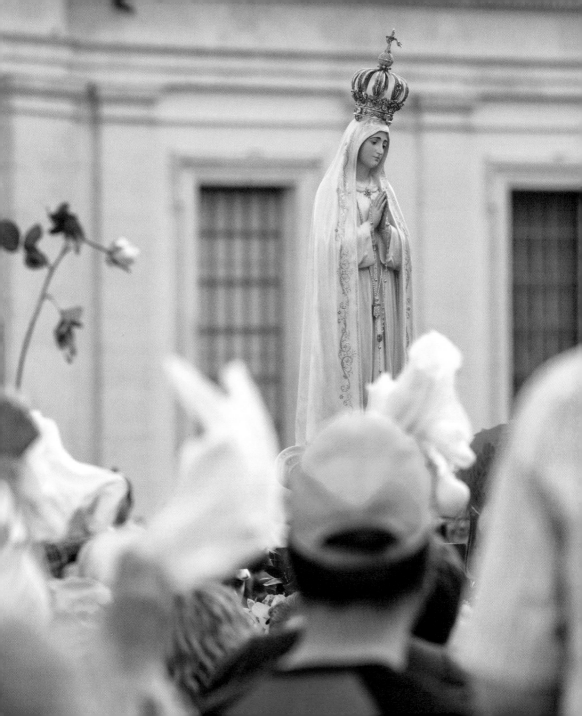

Refuge

The first piece of advice, when your heart is in turmoil, is the advice of the Russian Fathers: go beneath the cape of the Holy Mother of God. […] and wait there until there is a bit of calm: through prayer, through entrustment to Our Lady.

Address to Students of the Pontifical Colleges and Residences of Rome, May 12, 2014

Docility

May the Virgin Mary help us to be docile to the Holy Spirit, so that we may be able to value one another and converge ever more deeply in faith and love, keeping our hearts open to the needs of our brothers.

<div align="right">

Regina Coeli, *May 18, 2014*

</div>

Incarnation

The Holy Spirit, present from the beginning of salvation history, had already been at work in Jesus from the moment of his conception in the virginal womb of Mary of Nazareth, by bringing about the wondrous event of the Incarnation.

Homily of the Mass at the Amman International Stadium,
in Jordan, during the Pilgrimage to the Holy Land, May 24, 2014

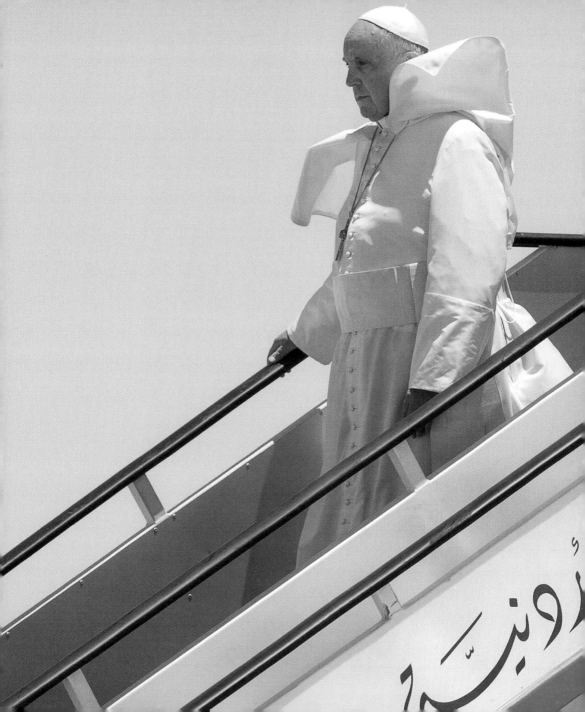

Following

Mary, Mother of Jesus,
you who accepted, teach us how to accept;
you who adored, teach us how to adore;
you who followed, teach us how to follow. Amen.

Homily of the Mass in Manger Square, in Bethlehem,
during the Pilgrimage to the Holy Land, May 25, 2014

Manger

Our thoughts turn to Mary Most Holy, who here, in Bethlehem, gave birth to Jesus her Son. Our Lady is the one who, more than any other person, contemplated God in the human face of Jesus. Assisted by Saint Joseph, she wrapped him in swaddling clothes and laid him in the manger. To Mary we entrust this land and all who dwell here, that they may live in justice, peace, and fraternity.

Regina Coeli, *in Manger Square, in Bethlehem,*
during the Pilgrimage to the Holy Land, May 25, 2014

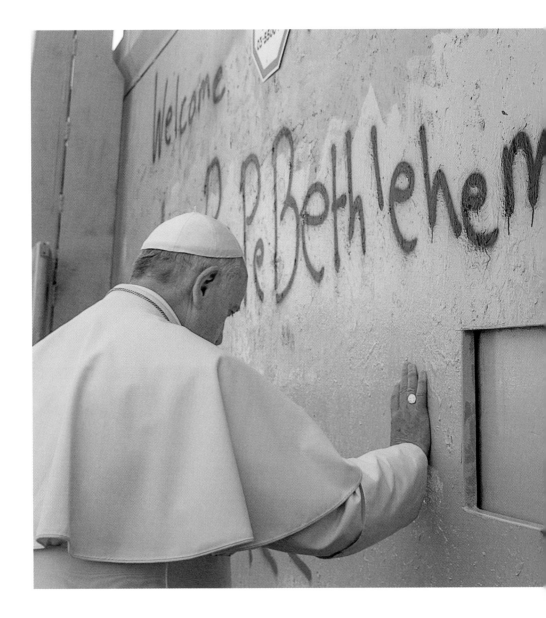

Seeking Refuge

When disunity makes us pessimistic, distrusting, fearful, let us all seek the protection of the Holy Mother of God. When there is spiritual turmoil in the Christian soul, it is only by seeking refuge under her cape that we can find peace. May the Holy Mother of God help us on this journey.

Ecumenical Celebration at the Holy Sepulchre, Jerusalem,
during the Pilgrimage to the Holy Land, May 25, 2014

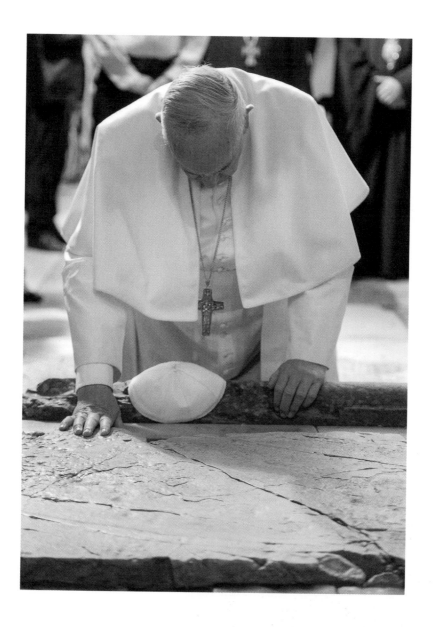

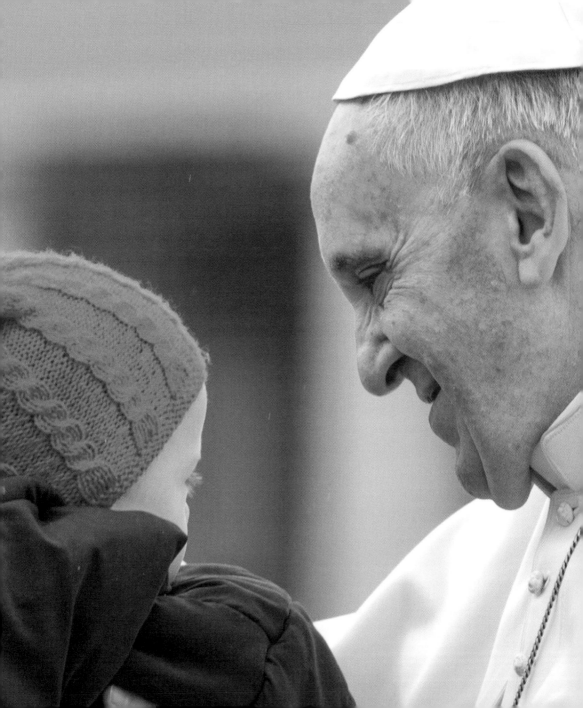

Upper Room

The Upper Room reminds us of the birth of the *new family*, the Church, and the hierarchy of our Holy Mother Church established by the risen Jesus; a family that has a Mother, the Virgin Mary. Christian families belong to this great family, and in it they find the light and strength to press on and be renewed, amid the challenges and difficulties of life. All of God's children, of every race and language, are invited and called to be part of this great family, as brothers and sisters and sons and daughters of the one Father in heaven.

Homily of the Mass with the Ordinaries of the Holy Land in the Upper Room,
in Jerusalem, during the Pilgrimage to the Holy Land, May 26, 2014

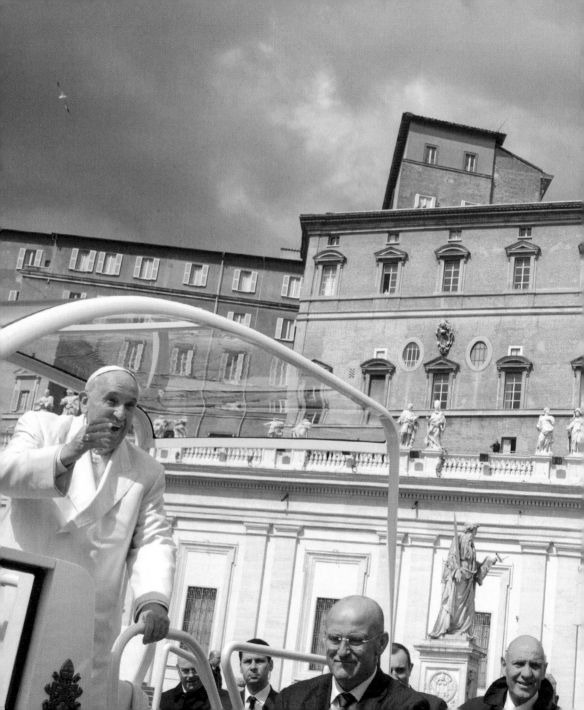

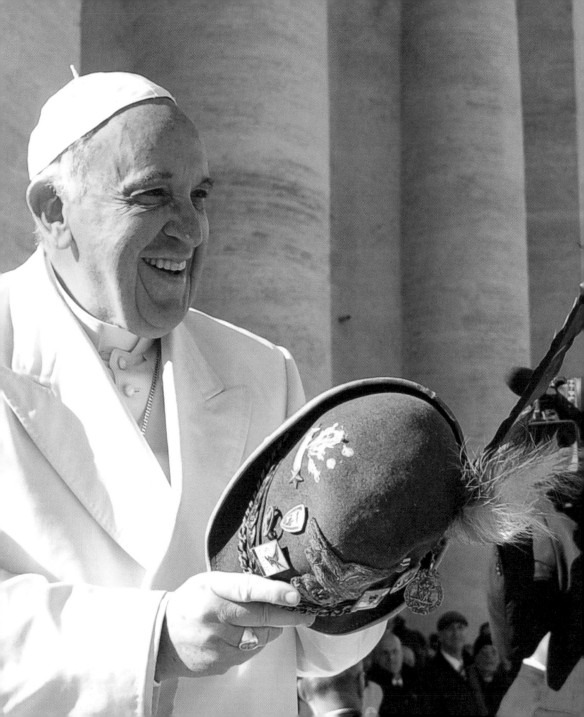

Readiness

Today, at the end of the month of Mary, is the Feast on which we remember her visit to St. Elizabeth. The Gospel tells us that, after the annunciation of the Angel, she went in haste, wasting no time, and went immediately out to serve. She is the Virgin of readiness, Our Lady of Readiness. She is ready right away to come to our aid when we pray to her, when we ask for her help, her protection is in our favor. In many of life's moments when we stand in need of her help, her protection, let us remember that she does not make us wait: she is Our Lady of Readiness, she immediately goes to serve.

Holy Rosary for the Conclusion of the Marian Month of May
in the Vatican Gardens, May 31, 2014

Queen

Together with Jesus, Mary our Mother accompanies us. She is already in the house of the Father as the Queen of Heaven, and this is how we invoke her during this time; as Jesus is with us, so too she walks with us; she is the Mother of our hope.

Regina Coeli, *June 1, 2014*

Weariness

May the Virgin Mary, your Heavenly Patron, whom you venerate with the title *Virgo Fidelis*, keep watch over you, your families, and your service. Remember her with faith, especially in moments of weariness and difficulty, certain that, as a tender mother, she will know how to present your needs and hopes to her Son Jesus.

Address to Participants in the Meeting of the Carabinieri Corps
on the 200th Anniversary of its Foundation, June 6, 2014

Memory

A Christian without memory is not a true Christian but only halfway there: a man or a woman, a prisoner of the moment, who doesn't know how to treasure his or her history, doesn't know how to read it and live it as a story of salvation. [...] With the Apostles that day was our Lady of Memory, who from the beginning meditated on all of those things in her heart. Mary, our Mother, was there. May she help us on this path of memory.

Homily on the Solemnity of Pentecost, June 8, 2014

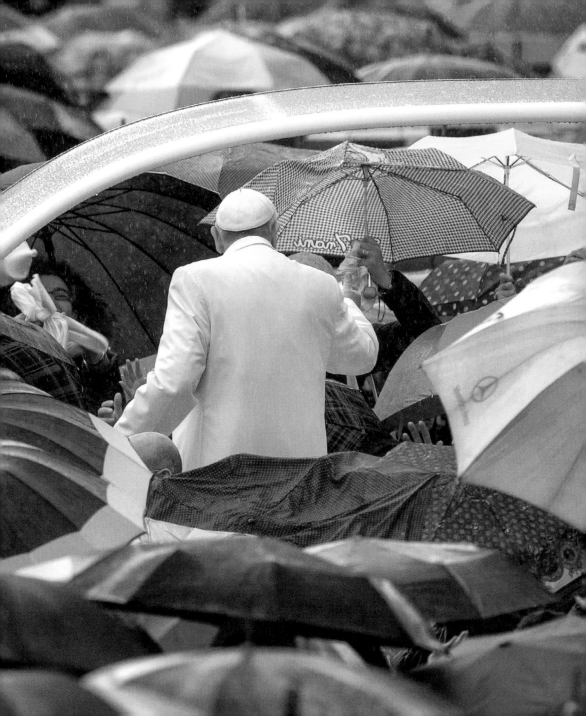

Holy Spirit

We turn to the Virgin Mary, who on that Pentecost morning was in the Upper Room, the Mother with her children. In her, the force of the Holy Spirit truly accomplished "great things" (*Lk* 1:49). She herself said so. May she, the Mother of the Redeemer and Mother of the Church, obtain through her intercession a renewed outpouring of God's Spirit upon the Church and upon the world.

Regina Coeli, *June 8, 2014*

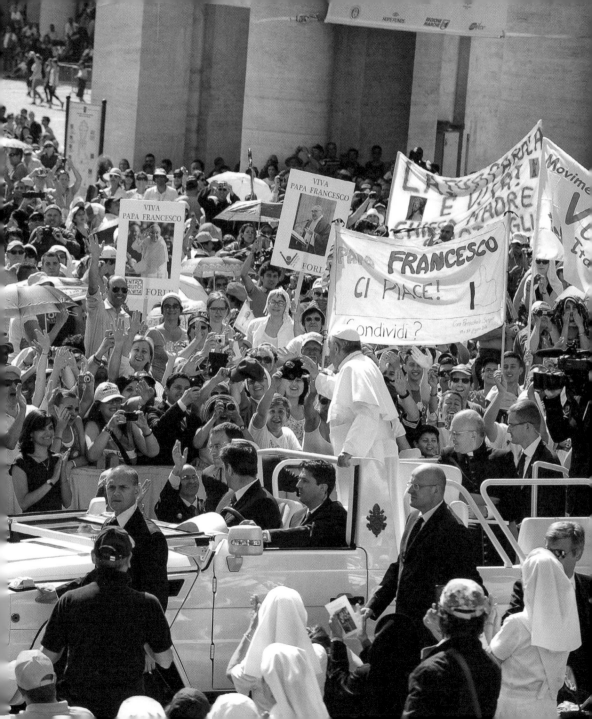

Home

Let us pray through the intercession of Mary, the model of humble and joyful evangelization, that the Church may become a welcoming home, a mother for all people and the source of rebirth for our world.

Message for World Mission Day, June 14, 2014

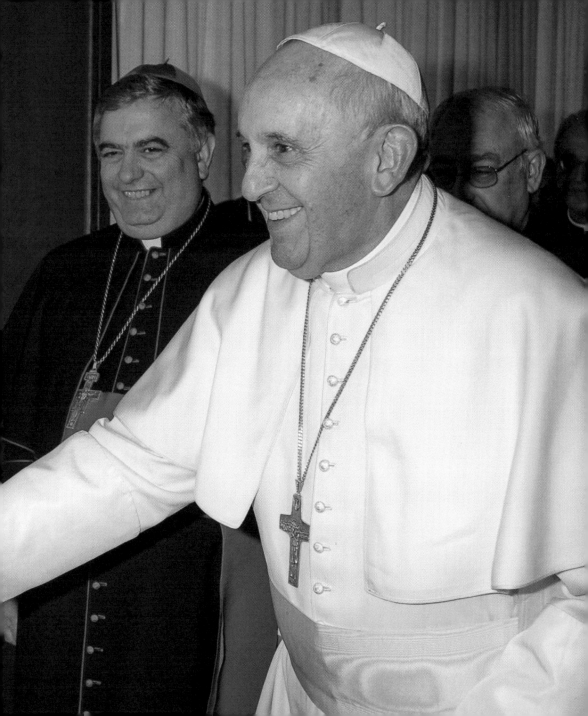

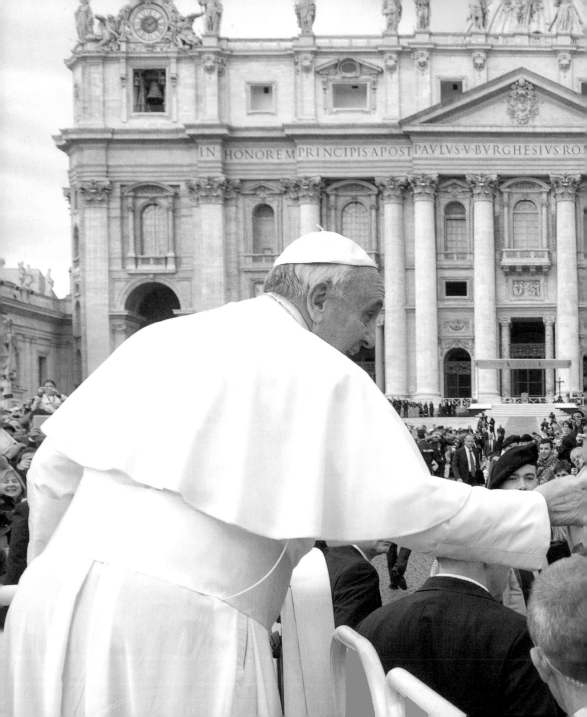

Happiness

Let us think of the Church as mother and let us say to our Mother Church what Elizabeth said to Mary when she became a mother, expecting a son: "Happy are you, because you believe!"

Opening of the Ecclesial Convention of the Diocese of Rome, June 16, 2014

Life

Mary, our Mother, Woman of the Eucharist […]. May she help you, help you always to be united so that, through your testimony as well, the Lord may continue to give life to the world. So be it.

Homily of the Mass in Piana di Sibari during the Pastoral Visit to the Diocese of Cassano allo Jonio, June 21, 2014

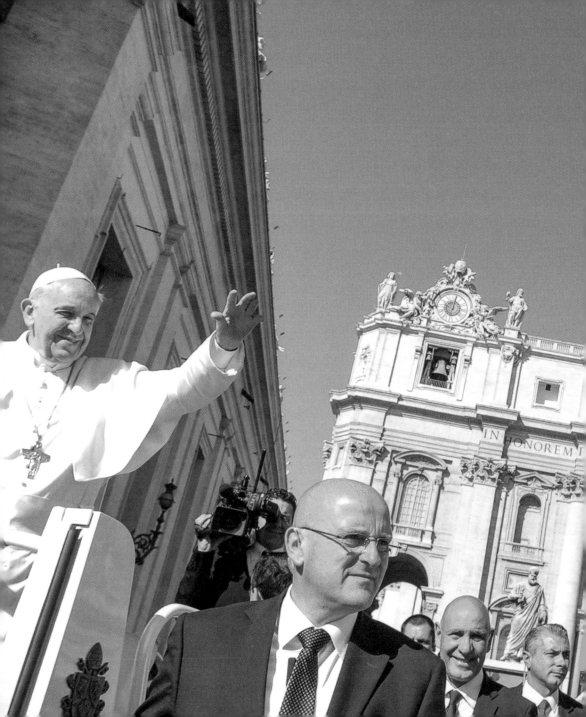

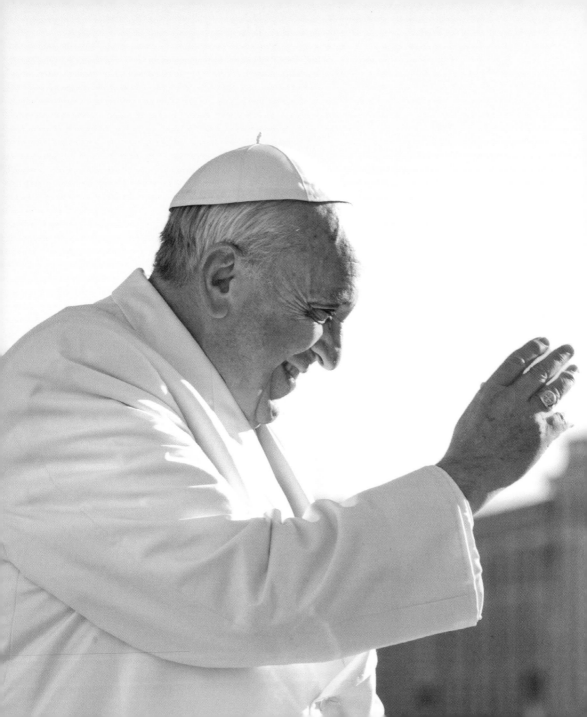

Eucharist

Jesus, Bread of eternal life, came down from heaven and was made flesh thanks to the faith of Mary Most Holy. After having borne him with ineffable love in herself, she followed him faithfully unto the Cross and to the resurrection. Let us ask Our Lady to help us rediscover the beauty of the Eucharist and to make it the center of our life, especially at Sunday Mass and in adoration.

Angelus, *June 22, 2014*

Prayer

Awaken in all of us a renewed desire for holiness: May the splendor of truth shine forth in our words, the song of charity resound in our works, purity and chastity abide in our hearts and bodies, and the full beauty of the Gospel be evident in our lives. […] Help us always to heed the Lord's voice: May we never be indifferent to the cry of the poor, or untouched by the sufferings of the sick and those in need; may we be sensitive to the loneliness of the elderly and the vulnerability of children, and always love and cherish the life of every human being.

Act of Veneration to the Immaculate at the Spanish Steps, December 8, 2013

———◆———

Image on the opposing page: The depiction of Mary Undoer of Knots (*Maria Knotenlöserin*) in the Romanesque church St. Peter am Perlach in Augsburg, Germany. Dating back to the 1700s, the painting is attributed to the Bavarian painter Johann Melchior Georg Schmidtner. The image is the inspiration for a Marian devotion made popular by Pope Francis. The first novena to Mary Undoer of Knots was written in 1998 by an Argentine priest, Juan Ramón Celeiro, for his parishioners. He obtained an *imprimatur* from the Archbishop of Paris in 2008, and today the novena has spread throughout the world in various languages and formats.

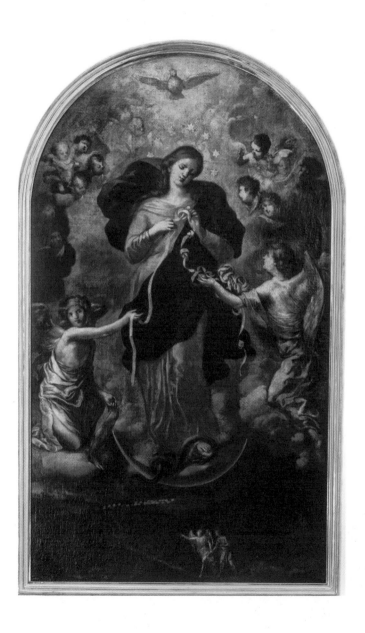

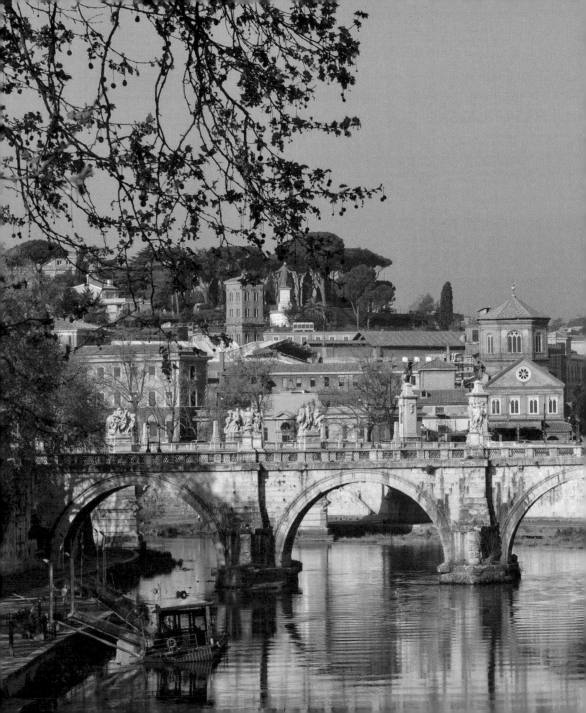

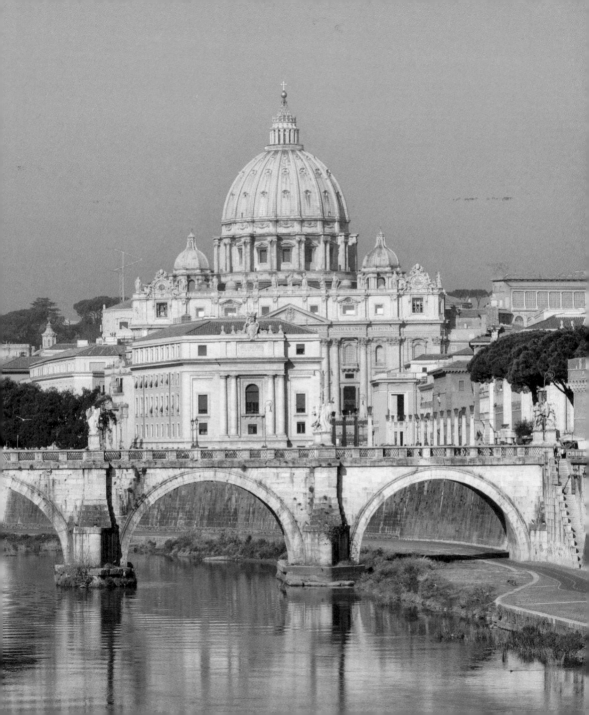

Index

First published in the United States of America in 2015 by
Rizzoli International Publications, Inc.
300 Park Avenue South
New York, NY 10010
www.rizzoliusa.com

Originally published in Italian in 2014 by
RCS Libri S.p.A.

Photographs © "L'Osservatore Romano" Photographic Service
except the following:
© Boris Stroujko / Shutterstock.com, pp. 12-13
© Giulio Napolitano / Shutterstock.com, p. 45
© Yulia Kotina / Shutterstock.com, p. 99
© Wilfried Bahnmüller - ARTOTHEK / Archivi Alinari, p. 263
© Lucian Milasan / Shutterstock.com, pp. 264-265

Introduction by Vincenzo Sansonetti, translated by Kristin Hurd
Art direction and layout by Ultreya, Milan

2015 2016 2017 2018 / 10 9 8 7 6 5 4 3 2 1

ISBN: 978-0-8478-4668-9

Library of Congress Control Number: 2015934400

Printed in Italy